COMPUTER
PHOTOGRAPHY
HANDBOOK

AMHERST MEDIA, INC. ■ BUFFALO, NEW YORK

Published by:
Amherst Media, Inc.
P.O. Box 586
Buffalo, NY 14226
Fax: 716-874-4508

Publisher: Craig Alesse
Senior Editor/Project Manager: Richard Lynch
Editorial Assitant: Michelle Perkins

Photos by: Rob Sheppard

ISBN: 0-936262-64-8
Library of Congress Catalog Card Number: 97-75207

Printed in the United States of America
10 9 8 7 6 5 4 3 2 1

Notice of disclaimer: The information contained in this book is based on the author's experience and opinions. The author and publisher will not be held liable for the use or misuse of the information in this book.

TABLE OF CONTENTS

INTRODUCTION

POSSIBILITIES . 6

Do you have to use Adobe Photoshop? 8

10 great things you can do with a computer 8

CHAPTER 2

INPUT AND LOOKING AT RESOLUTION . 11

Resolution and bits . 13

Scanners . 17

Photo CD's and other disks . 21

Considerations for choosing input equipment or media 23

Scanning is a craft, not a science 24

Low-end scanners and print film 25

Sharpening . 26

CHAPTER 3

DIGITAL CAMERAS 28

Resolution . 30

Viewfinder . 31

Storage . 32

Flash . 33

Many choices . 33

CHAPTER 4

LIKE A DARKROOM ON YOUR DESK 34

Software choices 34
Conflicts and lockups 35
Monitor settings 35

CHAPTER 5

GETTING THE IMAGE RIGHT 37

Cropping 37
Brightness and contrast 38
Color correction 39
Color saturation 40
Sharpness 41

CHAPTER 6

MAKING THE IMAGE EVEN BETTER 43

Cloning to correct problems 43
Selections 45
Lighter or darker by area 48
Selective color adjustment 49
Selective sharpness and unsharpness 50
Black-and-white 52
Steps to better photos 53

CHAPTER 7

CREATIVE ENHANCEMENT 55

Changing colors 56
Cloning to change the image 56

Filters and effects . 57

Morphing, warping, panoramics and more 60

CHAPTER 8

COMPOSITING . 63

New images . 64

CHAPTER 9

MAKING GREAT PRINTS AND MORE . 70

Inkjet printers . 70

Dye-sublimation printers 71

Other printers . 72

Service bureaus . 72

CHAPTER 10

12 IDEAS, EASY TO ADVANCED . 74

1. Pictures in a letter . 74

2. Letterhead . 75

3. Photo flyer and posters 76

4. T-shirts . 77

5. Greeting cards . 78

6. Party fun . 80

7. Photos for display 81

8. Newsletters . 83

9. Calendars . 84

10. Sports cards . 85

11. Labels . 86

12. Brochures . 87

Chapter 11

Storage 89

Floppies . 89
Hard drives . 90
Large capacity disk drives 90
Organizing and retrieval 93

Chapter 12

The Internet and Worldwide Web 94

E-mail . 95
Web sites . 99

Chapter 13

Conclusion 102

Appendix 1:

Photo File formats 103

Appendix 2:

Processing Power, RAM, Hardware and Software 105

Appendix 3:

10 Tips for Coping With the Computer 107

APPENDIX 4:

SOFTWARE IMAGE
PROCESSING PROGRAMS109

APPENDIX 5:

WEB SITES & DEMOS112

APPENDIX 6:

GLOSSARY114

INDEX119

CHAPTER 1
POSSIBILITIES

"...use your photos in ways you could only dream about in the past."

When computers and photography started to come together, they were seen by some as a curiosity ("Gee, isn't it clever how someone can get fish swimming in the sky?"). Or they were seen as a threat ("hey, don't be moving pyramids around!"). Many people thought of this marriage as somehow unholy, not "real" photography. For most of us, the cost was so high that we had no chance of even experimenting with the technology.

In the 90s, the cost dropped and suddenly a computer set-up to work on photos became possible for the average person. Today, manufacturers are making better and better hardware and software and you get more for your money! While early inkjet printers could cost over $800 for relatively low quality black-and-white capabilities, you can now get a color inkjet that does a better job with black-and-white, and offers true photographic-quality color images for half the price and less.

Software choices have exploded; you can now buy a whole suite of programs for the cost of one program just a few years ago. Digital cameras are dropping in price and increasing in quality. All of this has begun to stimulate renewed interest in photography.

You can now truly use your photos in ways you could only dream about in the past. Admire those lovely photo calendars you see in the bookstores every year? You can make your own featuring your photography for family and friends. Want to make a more personal greeting card for a good friend? Do it on your

"...create new images that express something about the way we see the world."

computer, with images you shot yourself. Want a stunning custom color print from your slide or negative? Print one out. Print out some and give them away to family and friends. The computer offers amazing possibilities for photography.

We need to think a little about the range of image possibilities, though. I "grew up" photographically reading Andreas Feininger's books (among others). He was a *Life* photographer who died a number of years ago, but his books still offer a lot to any photographer who wants to improve his or her work (check used book stores for copies). He talked about an important decision photographers need to make — deciding if a photograph really needs to be taken. To answer this question properly, you have to look more carefully at the subject.

We need to consider the same point about using the computer with our photos. The computer is a wonderful tool for helping us make our images better. It enables us to bring photos closer to the image we had in mind when we first took the shot, or to create new images that express something about the way we see the world. But it is also very easy to get seduced by all of the neat things that can be done. You can work so hard on an image that it becomes "perfect" in terms of using the technology, yet rather empty and barren in terms of making an image that people care about.

Feininger says it well in his book, *The Creative Photographer,* "To hold one's attention, a photograph must have something to give. It must have a meaning. It must be informative, educational, exciting, amusing or inspiring ... Not all subjects appeal to all people. As long as a photograph says something interesting and says it well, the photographer has not wasted his time."

We can use the computer to make our photos "give" more. That doesn't need to be anything fancy. Clean up a snapshot of a son or daughter so the child stands out better and gives our friends and relatives more of the subject.

We also have to remember that the computer cannot make a bad image good, in spite of rumors that seem to be spread by people who've never worked on a computer. Traditional photographic skills will always serve you well. You want to get the best images you can with your camera, whatever kind of camera it is, before you start working on them in the computer.

Using a digital camera is one way of combining photography and the computer, but it is not the only one. The traditional 35mm camera is still one of the best ways of capturing quality images for use in the computer. Combining new technologies with traditional photography opens up a realm of possibilities that are very exciting and promise to energize and vitalize everyone's photography.

Do you have to use Adobe Photoshop?

No. Photoshop is a wonderful, powerful program that is also complex, intimidating, expensive and offers a lot of features that won't be used by all photographers. There are many excellent and effective programs available at lower cost which are much easier to use. Some low-cost programs even offer certain features that Photoshop does not have. They even are good as a second program for the hardcore Photoshop user.

You won't see many direct references to Photoshop or any other program in this book. You can gain the benefits of combining photography with the computer no matter what the program you have, can afford or have time to learn. What you can accomplish on the computer has less to do with the program than with how well you can make the program perform for you. A practiced user with PictureIt! (a very low-priced program) will be able to accomplish much more with his or her images than someone who bought Photoshop because "that's what the experts use" but never has time to really learn it.

10 Great things to do with computer photography

1. *Make your photos better* — improve contrast, adjust color, brighten or darken areas so the image communicates better.

Cropping, and adjustment of contrast, brightness and sharpness, clarify the subject and strengthen the photo.

2. *Put pictures on the wall* — truly photo-quality inkjet printers allow you to make great prints of your photos whenever you want them.

3. *Make greeting cards, calendars and stationary* with your images, to get your photos noticed.

4. *Make your own newsletters, brochures and books.*

5. *Solve photographic problems* — get rid of a telephone pole growing from your spouse's head, delete annoying kids who shouldn't be in the picture, remove ugly power lines from landscapes.

6. *Expand the range of your image* — film has only so much range. With careful manipulation, you can actually bring out detail in a photograph that did not show up before.

7. *Repair photographs* — old, faded, cracked photos of grandparents and great-grandparents can be fixed and restored so they look as good or better than the day they were printed. You can knit together a tear in a negative, get rid of scratches and more.

Anyone can now repair and restore old family photos such as this one of the author's grandmother above (repaired at right).

10 THINGS TO DO WITH COMPUTER PHOTOGRAPHY:

1. Make your photos better.

2. Put pictures on the wall.

3. Make cards, calendars and stationary.

4. Make newsletters, brochures and books.

5. Solve picture problems.

6. Expand the range of film.

7. Repair photographs.

8. Change your photos.

9. Make a web site.

10. Play!

8. *Change your photos* — crop out an old girl or boyfriend, make pink flowers red, add a lion to your backyard, bring alien spacecraft to your city.

9. *Make a web site* — a web site can be a place for friends and relatives to see your latest photos of the kids or you can use your photos as a part of a business you promote on the internet.

10. *Play!* You can have a lot of fun with digital stuff. For example, take pictures at a childrens' party with a digital camera (you can also use a Polaroid camera and scan in the prints), bring them into the computer, alter them, and print them out for face masks. Or photograph kids dressed up in costumes in your backyard, then put them into different locations, such as an exotic city from a stock image that came with your software.

CHAPTER 2

INPUT AND LOOKING AT RESOLUTION

To work with an image on the computer, you have to get it into the computer. Basically, you've got to get a photograph translated into digital data. That used to be hard, at least if you wanted quality. That's not true today. You have the choice of many excellent ways of getting images into the computer, and prices on peripherals that change an image to digital data are dropping every day.

Digital cameras are fun to use and the technology is rapidly improving. Images are already in digital data form, so they only need to be transferred from camera to computer. However, traditional film-based photography will continue to be the main way of taking photographs for quite some time. Traditional film even offers a number of advantages over digital cameras.

ADVANTAGES OF FILM-BASED CAMERAS:	ADVANTAGES OF DIGITAL CAMERAS:
1. Lower-priced cameras and lenses than digital	1. Instant results (no waiting for processing)
2. Tremendous range of equipment	2. Direct transfer to computer (no scanning)
3. Very high resolution	3. New, fun way of taking photographs
4. Better tonal range of image	4. Very "cool" (no question that the "cool" factor is important here)

If you are using a traditional camera and film, what do you use to move that photograph into the computer? Flatbed and sheetfed scanners, slide scanners, photo-print scanners, Photo CD, FlashPix CD, Picture Disk, Web-Processing, Floppy Shots and more are available. How do you decide which one is right for you?

There are many options to get images into your computer. Above, a Nikon flatbed scanner for prints; right, a Canon 35mm film scanner.

Above, a Kodak Advantix scanner for APS film. Right, a Polaroid flatbed scanner.

The good news is that they all work. Every one of these input devices or disks will get your film-based photos digitized so that you can use them in the computer, whether your output is for a card to grandma done on an inkjet printer or you are having your image printed in a magazine.

The bad news is that they all work differently. What's best for one person's situation might not be best for another's. "Best" is a slippery term that can mean different things for different photo-

graphic and computer uses. It all depends on your budget, the type of film medium you are working with, the end results needed and so on.

Resolution and bits

You have to understand resolution in digital terms from the start because it affects what you put into the computer and what you get out. Unfortunately, resolution in the computer world can be confusing because it changes depending on the situation. In traditional photography, a lens has a certain resolution, good or bad, and it basically stays the same (unless you damage the lens). A slide or negative is capable of a certain resolution and it does not change. These references to resolution refer to sharpness, while resolution with the computer refers to the amount of information in the image.

To understand resolution, don't let all of the numbers distract you. You have to think of how the images will be used first. Monitor resolution is different than scanner resolution is different than printer resolution — and knowing which way you will display those images tells you which resolution you need.

Resolution is described in two ways: per defined area (per square inch) and over the entire image. That difference can be quite significant. It is like looking at how many golf balls covering a green fit in each square foot (resolution per area) and how many golf balls fit in the whole green (image resolution). Computer resolution is then defined by how many pixels (golf balls) are included. "Pixel" is short for picture element. It is the smallest available picture point as defined by the computer and software.

Area resolution is usually described as dpi (dots per inch) or ppi (pixels per inch). These are often used interchangeably, although dpi usually refers to the resolution of a peripheral, like a scanner, while ppi usually refers to the actual pixels per area of an image. Monitors, scanners and printers have their resolution described in areas (dpi) because the image sizes can vary. Scanned photos (such as Photo CD's) and digital cameras have resolution described as a total: how many pixels are in the whole picture (usually described by the number of pixels along the width and height of the image, e.g., 1280x960).

Monitors are fairly low in resolution, in the order of 72-120 dpi. This means that there are 72-120 pixels along an inch — not very many, but fine for the monitor. Bigger monitors make it easier to see photos — the dpi for each area (an inch) doesn't change, but there are more inches available, so you see the pixels better and more dots fit on the screen. Most important is the fact that monitor resolution has nothing to do with image resolution.

Scanners and printers have a range of dpi resolutions. Higher dpi settings for scanners allow more detail to be scanned from a

A large monitor is very important for making work on an image easier. Above is a17-inch monitor from Sony.

photo. A scanner set to 300 dpi, for instance, will capture twice the detail of 150 dpi on the same image.

Printers are a little different. While a 300 dpi image will give far better looking prints than 100 dpi, 300 dpi is also approaching a point where higher resolutions add nothing (and can even hurt). Higher resolution for a printer is about how it lays down ink, not how it uses the pixels of an image. Most inkjet printers are optimized for 300 dpi photos, regardless of the printing dpi of the unit (higher dpi's make a difference with image tone and text).

Photo-realistic printers now give you the chance to make superb prints at home, when you want them. This is a Canon inkjet printer.

Once an image is scanned and made into an electronic file, it now has dimensions and a finite number of pixels (like the total golf balls on the green). The dpi or ppi is now only important in terms of how big the photo can be printed or output. The image itself will be described by the number of pixels along each side (1536x1024, for example). This is a total number of pixels that can be then described in ppi, but as ppi is changed, so does the physical size of the photo output. For example, at 300 ppi, the pixels (golf balls) sit tightly grouped within the photograph. At 100 ppi, the pixels (golf balls) are spread out to a third the number per inch, so the photograph becomes larger, since it has a finite number of pixels (golf balls) and all of them are used.

How does all of this relate? First, the monitor resolution cannot be changed. So a photo must use up its pixels in a certain way. If it is displayed so each pixel matches each one on the monitor, then the photo (with its finite number of pixels/golf balls) will be spread out, possibly becoming quite big. If it is displayed at a smaller size, then you can't see every pixel of the photo. That's why we usually enlarge the view of an image on the screen to do detailed image editing on it.

With scanning, it pays to scan at the highest resolution you can appropriate to the end use. If you are outputting your photo to a printer at 300 dpi, you need to have an image with 300 dpi. The dpi requirement stays the same no matter what the size of the image — big images will have more inches, resulting in more "dots" total, but whether the photo is 4x6 or 8x10 inches when printed, it must have the 300 dpi for best quality. That's why larger images have such big files — they include a lot more pixels. But if you are going to use the image where fewer ppi are needed, like on the web where 72 ppi is all that is required, you are wasting time, storage space and your work with a larger file. (Note: Programs sometimes import images from scanners at different dpi's, depending on the brand of the software.)

Also, you may need to print out an image in a newspaper or magazine. Here, a photo is described in different terms — as a half-tone screen. You'll hear it referred to a 72-line, 100-line, 150-line or more screen half-tone. The higher the number, just like in the area-based computer resolution, the more detail that is captured and printed. Most printers like a computer file to have a ppi of 1.5 to 2 times the half-tone screen number. For example, a 150-line half-tone would need a file with 225-300 dpi at the final image size. The latter is important. Your photo must be the size of the printed image (or larger — the printer can reduce it) and at the needed resolution (300 dpi for the 150-line screen).

"That's why larger images have such big files — they include a lot more pixels."

RESOLUTION NEEDS:	
Web pages	72-120 dpi
Prints from inkjet printer	200-300 dpi
Prints from dye sublimation printer	200-400 dpi
Newspapers (72 line)	110-140 dpi
Printed pages at 100 lines	150-200 dpi
150-line halftone	225-300 dpi

These resolutions are at the actual size of the final image.

RESOLUTION REFERENCE CHARTS:

These charts show the relationships between image size, file size and resolution. Resolution in the computer can be confusing because it is not a constant. You have to think in terms of the amount of information stored, which is why is it often helpful to compare file sizes rather than resolution. Use these charts to help in your scanning, filing and output decisions. Numbers have been rounded off for ease of understanding.

INPUT RESOLUTION:

Scanning decisions have to be made based on the relationship of resolution and original size. The first chart shows consistent file size; the second shows consistent dpi.

ORIGINAL (IN INCHES)	SCAN RESOLUTION	FILE SIZE
8x10	300 dpi	24.8 MB
4x6	600 dpi	24.8 MB
1x1.5	2400 dpi	24.8 MB
(35mm)		

ORIGINAL (IN INCHES)	SCAN RESOLUTION	FILE SIZE
8x10	300 dpi	24.8 MB
4x6	300 dpi	8.4 MB
1x1.5	300 dpi	0.4 MB
(35mm)		(400 KB)

OUTPUT RESOLUTION:

Output decisions have to be made on the basis of image size and needed resolution of the printer, the web or other end use (*Note: print size is usually stated with the smaller number first, while pixel size is often given with the larger number first*). The first chart shows consistent file size and pixel dimension.

DPI	SIZE (IN INCHES)*	SIZE IN PIXELS*	FILE SIZE
2400 dpi	1x1.5 (35mm)	3600x2400	24.8 MB
300 dpi	8x12	3600x2400	24.8 MB
150 dpi	16x24	3600x2400	24.8 MB
72 dpi	33x50	3600x2400	24.8 MB

DPI	SIZE (IN INCHES)*	SIZE IN PIXELS*	FILE SIZE
300 dpi	8x12	3600x2400	24.8 MB
72 dpi	8x12	860x580	1.42 MB
300 dpi	4.7x7	2100x1400	8.43 MB
300 dpi	4x6	1800x1200	6.2 MB
300 dpi	3.3x5	1500x1000	4.3 MB

Scanners

Scanners offer optical and interpolated resolution. Optical resolution is what the scanner actually sees with its sensors. Interpolated resolution is what the machine "guesses" is there beyond what it can see by interpreting the information with software. While a higher resolution will give more detail, optical resolution is always better than interpolated resolution because it is based on what the scanner actually sees with its hardware.

Scanners also have a certain color depth, today most commonly 30-bit, although there are some 36-bit scanners available. The color depth refers to the ability of the scanner to see nuances in color per each channel of color, red, green and blue (RGB). A scanner that recognizes 10 bits of color per pixel is 30-bit (10 bits x 3 channels). When 12 bits per channel can be seen, the scanner is a 36-bit scanner and will see some fine color details that the 30-bit unit might miss.

Small-Print Scanners — small scanners that easily fit the desktop. They scan standard-print-sized images and typically take up to 4x6 inch prints. Usually have optical resolution of 200 dpi.

Little desktop scanners work well to quickly scan in regular 4x6 prints. This is one from Epson.

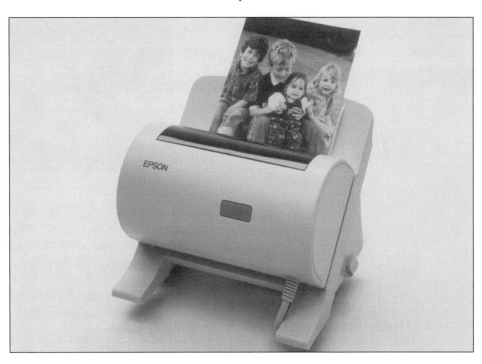

Advantages — extremely easy and convenient to use and set-up. Small file size makes images easy to use on computers with low RAM. Very low cost.

Disadvantages — small file size limits how big images can be used. Limited ability to adjust scans. Can't scan larger images, slides or negatives.

Special Considerations — a great way to make quick newsletters, add photos to a report, and especially good for dressing up the kids' schoolwork. Print photos for friends and relatives, or put together a quick brochure of good-looking images at moderate size.

Sheetfed Scanners — sheet-fed scanners also have a very small size or footprint on the desktop, and scan a larger print up to 8.5x11 inches. The photo is pulled through the machine, usually at an optical resolution of 300-400 dpi.

Compact sheetfed scanners take up little room on the computer work area, but you do have to keep the print from hitting obstructions. This Hewlett-Packard scanner fits behind the keyboard.

Advantages — take up minimal space. Larger prints result in more detail. Controls are available to adjust scans for color, brightness/darkness and resolution. Easy to set up.

Disadvantages — moving scanned-page can cause less sharpness and distortion if the print is disturbed during scan. Don't have color-depth or dynamic range of higher-end flatbeds. Can't scan thick objects.

Flatbed Scanners — these scanners have a flat glass surface for scanning photos. The image stays still as the scanning sensor passes across it. Mostly for images up to 8.5x11 inches or slightly more (higher-priced units often can work with bigger images). Higher-priced units also have more resolution, a higher dynamic range and more color depth. These scanners include software for adjusting resolution, brightness and color during the scan. Resolutions range from 300 dpi (low-priced units) to 1200 dpi and higher.

Advantages — easily scan in small to large prints. Larger prints result in larger files that can be used for bigger prints or other outputted images and larger files offer more detail. Can scan objects directly when they are placed on glass.

Flatbed scanners, like this one from Optic Pro, offer a lot of capability for very reasonable prices.

Disadvantages — take up lots of space on desktop. Some units are harder to set up because of special hardware and software needs. Software may be harder to understand if there are numerous controls.

Special Considerations — slide/transparency adapters can make unit more versatile, but scans are never as sharp as scans made from slide scanners.

Film Scanners — scanners specially designed to scan from the small image size of a slide or negative. They have very high resolution (in the 2000-2700 dpi range), needed for the small scan area. Desktop footprint is small. They all include software for adjusting resolution, brightness and color during the scan.

Advantages — for scanning in slides or negatives directly, there is no more convenient or higher quality scanner available. Since you don't scan from a print, you can get more of the image's color and tonal range that was originally in the slide or negative.

Disadvantages — higher priced than most other scanners. Usually limited to only slides or negatives. Only a few have the color depth or dynamic range of the best flatbeds.

Below right are a couple of dual-format scanners, Konica's on the left, Minolta's on the right. They allow you to scan slides, negatives and APS film.

Special Considerations — you must take special care in scanning such a small image area. A clean anti-static brush and a can of compressed air will keep the scans free of dust and dirt.

Video Frame Grabbers — specialized adapters with packaged software that allow you to take still images from video or a camcorder. Units plug directly into the computer. Standard video resolution is 640x480 pixels, although most will capture at higher rates by capturing information over several fields of video information.

Video frame grabbers, like Play's Snappy, are an easy way to get images into the computer if you have a camcorder. You can grab still shots from video (up to 640x480 pixels), capture higher resolution images (up to 1600x1200 pixels) from slides, negatives or prints, or you can even bring moving video into the computer (although not at full video quality).

Advantages — if you already have a camcorder, this device allows you to capture video, prints, slides or negatives directly. You can scan in a great number of images (such as a large slide file) quite cheaply.

Disadvantages — tonal range and color depth may be limited due to limitations of tonal and color range possible with a camcorder. This will vary by camcorder and capture unit.

Special Considerations — take special care in scanning small image areas of slides and negatives. For scans from video, be sure the video is shot at the highest quality recording speed (SP, never use EP) and use high quality tapes.

Photo CD's and other disks

A Photo CD is a disk with images professionally scanned in at a service bureau. The disk is read in the CD-ROM drive of the computer which makes this an extremely accessible form of image input. A standard Photo CD comes with five resolutions, but a sixth is available on ProPhoto CDs.

Photo CD — stores 100 images, making it a very compact form of storage, and you don't have to fill it up the first time your service bureau puts photos on it. Photo CD images usually need at least sharpening and brightness/contrast adjustments. Shop for a service bureau or lab based on price and quality. There is a difference!

PHOTO CD RESOLUTION

SCAN RESOLUTION	AREA RESOLUTION	QUALITY NOTES
Base/16	192x128	very low resolution, thumbnails
Base/4	348x256	low resolution, limited uses for Internet
Base	768x512	okay for small images, newsletters or cards
4 Base	1536x1024	good quality for many photographic uses
16 Base	3072x2048	excellent quality, used for publications
Pro Photo CD	6144x4096	very high quality, suitable for large images

Advantages — low cost for the resolution, tonal range and color depth. Easily used by almost anyone with a computer since all modern CD-ROM drives will read them. Stable images that can't be accidentally erased. Can be used for storage. Highest level professional results possible.

Disadvantages — variability from lab (or service bureau) to lab (you have to make your own tests and compare). Costs become high if many images have to be scanned. Less convenient — can't get images instantly into computer since you must send them out to service bureau. Standard Photo CD's only permit 35mm scans. Larger formats require the Pro Photo CD.

FlashPix CD — similar to a Photo CD in that images are professionally scanned and put onto a disk. The standard resolution of a FlashPix CD or disk is 1536x1024 pixels, but this is actually a multiple-resolution image file format. Only the resolution needed is accessed, resulting in faster usage of parts of the image as you work on it. For software that uses this format, images can be processed faster and with less RAM on the computer. Available on CD (multiple images) or floppy disk (one image per floppy).

Advantages — image-processing software can use a low-resolution image on screen as work is performed on it, yet the higher resolution is instantly available. This allows "slower", less-powerful computers to work on high-quality, higher resolution images. Software that supports FlashPix will choose the appropriate resolution automatically.

Disadvantages — not all older programs can use it. Resolution at present is limited to 1536x1024 pixels when the image is scanned to a disk.

Photo processors offer several ways of encoding photos on to computer disk. FlashPix is a format that is easy to work with if your program recognizes it.

Floppy disk images — Known by Kodak Picture Disk, Floppy Shots, Disk Pix and other proprietary names. These are low-resolution images that fit on a floppy disk. Processors frequently offer a package that includes the processing of film and putting its images all on a disk. Resolution is usually in the range of 512x768 pixels and images are mostly stored in a JPEG format.

Advantages — very inexpensive way of getting images into the computer. Very easy to use and accessible on nearly any computer. Low resolution images "process" very fast and can be used in many applications that don't require high resolution.

Disadvantages — low resolution, tonal range and color depth.

Considerations for choosing input equipment or media

1. What do you need images for? If you only want to do small greeting cards or put images on the Internet, you don't need high resolution scans. At the other extreme, if you want to work on very high quality images for professional use, you will need high resolutions with high color depth and dynamic range.

2. How much room do you have? Small sheet-fed scanners take up very little room and offer good quality for images up to 8.5x11 inches in size. Flatbed scanners

CONSIDERATIONS FOR CHOOSING INPUT EQUIPMENT:

1. What do you need images for?

2. How much room do you have?

3. What will you be scanning?

4. What is the best quality you can get in your price range?

offer the most flexibility in use, but they do take up more space.

3. What will you be scanning? Prints can be scanned on most scanners. Slides and negatives really need to be scanned with a 35mm scanner. Slide adapters for flatbeds really don't give the same results. Advanced Photo System (APS) film needs an APS scanner.

4. What is the best quality you can get in your price range? Compare optical dpi, color-depth and dynamic range. The higher the optical dpi, the more detail you'll be able to dig out of any image, although you don't always need the maximum. The more bits per color (e.g., 10-bit color compared to 8-bit color) scanned, the greater the color depth. As the dynamic range increases, so do the tones and color that make up an image.

Scanning is a craft, not a science

Really good scanning requires some practice and experience, just like any other craft. Getting the best scan you can affects how easy it will be for you to work on the image later. If the right details aren't on the scan, it is difficult to get them back later. Scanning is also very subjective. What one person likes or finds works best in his or her situation won't necessarily do the same for you. Here are some tips to consider for better scans:

1. *Highlights and shadows.* You can't always get both the highlights and shadows of an image to scan well. Decide which is most important, then get a scan that treats the highlights or shadows the best way the equipment can. You can also scan with less contrast so more detail shows up in highlights and shadows, then increase the contrast in the software.

2. *Brightness and contrast.* Brightness and contrast apply to all tones in an image. Look for a brightness/contrast combination that looks good on the preview and retains detail where you need it. Play with both controls as they greatly affect each other. If you have to, favor a lower contrast with higher brightness, as you can always adjust to higher contrast and lower brightness. It is not so easy to adjust the other way.

3. *Color casts.* You don't need to make all the colors perfect in the scan. That may be very difficult, and time consuming. You can, however, get rid of color casts that will give you problems later. Find a neutral color area and try to make it look neutral in the preview.

SCANNING CONSIDERATIONS:

1. Selecting highlight and shadow points.

2. Brightness and contrast control.

3. Correct color casts.

4. Selecting size and dpi.

A flatbed scanner, such as this Hewlett Packard model, is a convenient way to get photos into your computer. Any scanner takes practice to get the best image scans possible.

4. *Size and dpi.* Scan at the size you need or just slightly larger. If you scan much larger, you will waste RAM and storage space with a file larger than you need. If you scan smaller, you will have a hard time getting the quality needed if you have to blow it up. Select a dpi appropriate to the end use of your image.

Low-end scanners and print film

One challenge of lower-priced slide and negative scanners is that they do not have the dynamic range of more expensive scanners. But these scanners are incredibly convenient and do a wonderful job for the price. One way to compensate is to use print film, which handles a longer tonal range than slide film. This means it sees more steps of tones (or brightness) from black to white in the original scene. When using a scanner that is less able to discern dynamic range, start with print film because it captures more tones. If you start with slide film, tonality is already somewhat compressed.

You'll note this refers to scanning the negative. Scanning prints will not give you the full range of the negative. What ends up on the print is highly dependent on the skill of the processor and the printing paper used. For best results, the negative must be properly exposed. Underexposure is the kiss of death and will

"...these scanners are incredibly convenient and do a wonderful job for the price."

not result in good scans or good prints (you will lose tonal range). With print film, slight overexposure is always preferable to under-exposure.

Sharpening

All scans need some sharpening in an image processing program to look their best. Use the unsharp mask sharpening tool if your program has one or use light sharpening a little at a time. With unsharp mask, set the controls to a moderate amount of sharpness with a low radius and a threshold of 7-15. Use it more than once if needed.

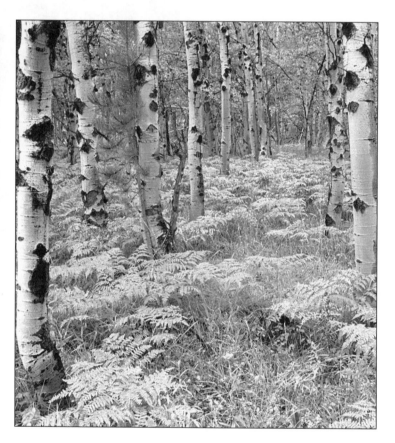

Scans generally need sharpening to give them the quality the original had. The unsharp mask tool is one of the best. No sharpening tool can make an out-of-focus object sharp, however. Your image has to be sharp to begin with.

Be careful not to over-sharpen. Sharpening tools not only affect the image, they also sharpen the grain, which you may not want to see. If you try a certain amount of sharpening and the grain suddenly jumps out at you, back up, undo it and try with less. Another trick: if your program allows you to separate the image into channels (RGB), try the despeckle or dust filters on one of the channels (red or green usually work) to reduce the effect of the grain.

Over-sharpening also makes edges look funny. Strong edges will get color fringing and "ringing", a banding of dark or light lines along the edge. This can make an image look awful very

quickly. However, you can over-sharpen for a creative effect, too. Push it far enough so it looks like something you meant to do, rather than a mistake.

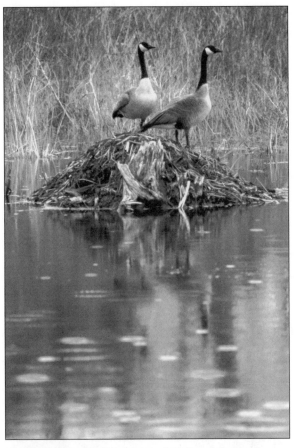

Over-sharpening is not good as it can increase the appearance of grain and create an unattractive "edginess" to sharp lines in the photo.

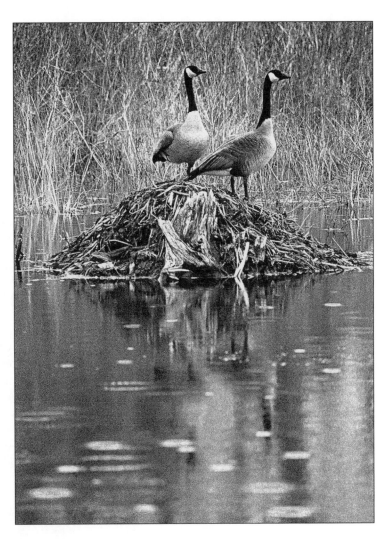

CHAPTER 3
DIGITAL CAMERAS

Digital cameras give you the chance to take a picture, then get it "processed" immediately. Just download the images into the computer and you've got photos! Instead of film, these cameras use a special light-sensitive electronic chip and store the image information electronically.

A megapixel digital camera with a sleek, yet traditional SLR design from Olympus.

This technology is changing so fast it is hard to say what will be available from year to year. Low-priced digital cameras keep getting better and better in terms of resolution, but don't yet offer

the resolution capabilities of traditional 35mm photography. That technology is still a little in the future for the average user (unless you have a very big budget).

Unfortunately, many people don't seem to understand what digital cameras really are. Let's look at an analogy. Cellular phones are not the equal of standard phones in sound quality. Still, cellular phones have exploded into the marketplace. They provide a great product in a parallel universe, not as a replacement to traditional in-line modular equipment.

Digital cameras are like that. Today, not in some distant future, digital cameras are:

1. *Instantaneous.* The LCD monitor on most models shows you what the picture looks like as soon as you take it.

2. *Instructional.* With that LCD monitor, you can see if you like the photo or not. Evaluate your shots as you go, get rid of the junk and reshoot when needed.

DIGITAL CAMERAS ARE:

1. Instantaneous.

2. Instructional.

3. Fascinating.

4. Economical.

5. Useful.

6. Stimulating.

7. FUN!

Some digital cameras have LCD monitors on the back. The Nikon CoolPix 900 has a rotating lens and sensor to allow a larger lens to be used for better quality and to give the photographer new shooting angles.

3. *Fascinating.* Take a picture of anyone and if they know you have that LCD monitor, they will be by your side in a flash to see the results.

4. *Economical.* If you shoot a lot of pictures, the digital camera becomes very economical (after the initial investment) because you no longer have to take your photos to the local lab for processing. Since you can see what you have as you go, you also don't need to take a lot of extra shots to be sure you "got the shot."

5. *Useful.* Digital cameras offer quick photos for family or business newsletters, for kids' school reports and even just to add a photo of the kids in their new soccer uniforms to a letter to grandma and grandpa.

6. *Stimulating.* Many models offer new ways of handling a camera. For example, a swiveling lens allows the camera to take new perspectives of familiar subjects.

With an LCD monitor and a rotating lens, you can literally shoot from the ground without putting your head on the ground, too. The vertical streak through the sun in the photo is typical of digital cameras — it occurs because of the way the CCD sensor reacts to very bright spots of light and cannot be avoided at this point in CCD design.

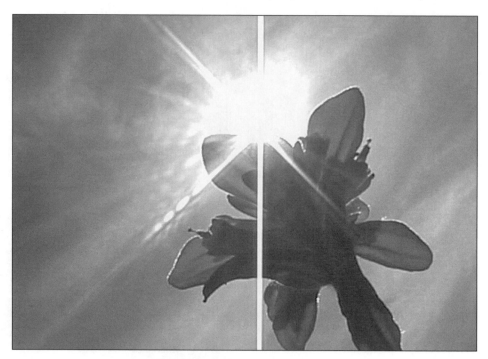

7. *FUN!* Digital cameras are fun! They encourage you to get out and experience photography in ways you might never have tried before.

There is a little problem that all cameras with an LCD monitor share: they devour batteries. The more you keep that monitor on, the faster the batteries are used up. Rechargeable batteries help, especially ones that are designed for the camera, but you'd better bring spares. Never go anywhere without three sets of batteries: one in the camera, and two spares. Hopefully, manufacturers will begin to address this problem more fully in the future — maybe doing something like incorporating small lithium batteries as used in camcorders.

Resolution

The resolution of the low-cost digital cameras is, in spite of all of the advertising hype of "high resolution", low compared to traditional 35mm cameras. It is really a mistake, however, to think these cameras have to match 35mm. They feature different, parallel uses, but do not replace regular cameras. Digital cameras

offer fun things to do with images that you couldn't do before (like sending a postcard from Europe with a photo that you took that day!).

Resolution varies a bit from camera to camera, but basically, goes from the equivalent of a Base/4 Photo CD image (see page 21) to a Base image (a good beginning level) and higher. The higher the quality, the more you will have to pay.

Viewfinder

Some cameras come with traditional optical viewfinders, some with LCD (liquid crystal display) monitors that show what the sensor sees, and some have both. A traditional viewfinder makes the camera act like a traditional camera. Also, since the camera body can be held tight to the face, you can often get sharper images because the camera can be braced better and held steadily.

Agfa's ePhoto digital cameras offer a rather unique design that makes photography a little like watching a little TV. Just shoot when the best shot comes on.

An LCD monitor allows you to actually see what the lens is seeing — like a traditional SLR camera. This means that close-ups have accurate framing — what you see is what you get, so you don't miss your subject (possible with an optical viewfinder). An LCD monitor also allows playback. You can see what you've shot, decide if you really got the shot, then either move on or retake the shot (a great tool for students of photography). It also allows you to delete images you don't want. Since monitors eat up batteries, don't leave them on any more than you have to.

Storage

One key element in chosing the best digital camera is to look at storage. Early models kept it simple by storing everything inside the camera. Images were then downloaded from the camera to the computer. Most now use small removable storage media in little cards that you can take in and out of the camera. They work sort of like 'digital film' cartridges. This allows more flexibility in how many images you can store. New memory card readers make downloading images faster and more convenient, too.

Flash cards are sometimes referred to as digital film because they can be removed from the camera like film. SanDisk also sells a small reader to make downloading images faster and easier than plugging the camera into the computer.

Look for storage that is appropriate to your needs. If you are always shooting around home and business, you don't need a huge amount of storage. If you are traveling, you may want to take more images than a camera with a single memory card can store; opt for additional storage cards. If you travel with a laptop, you can download images as you shoot.

When comparing storage, be sure to check resolution. Some cameras have several resolution possibilities. More low resolution images can be kept in the same amount of storage media than high resolution shots. With other cameras, the resolution stays the same, but the way the image is filed changes. Digital photos are often compressed to fit in limited storage areas. Lots of compression will degrade the image quality, even though the resolution doesn't change. High storage numbers for a limited amount of megabytes of storage means high compression.

Flash

You don't get a lot of options with the built-in flash that comes with many of the digital cameras. However, it can let you get better images inside, brighten colors in low light and on cloudy days, and fill in dark shadows on sunny days. Look for the ability to turn the flash on and off manually. With that option you can tell it to fire, even on a sunny day. If you ever shoot people with hats on when the sun is out, having the flash fill in shadows can make the difference between a terrible and a usable image.

While low-priced digital cameras cannot match the image from a 35mm camera, they offer convenience and fun in ways not possible when using film. That's why the major film manufacturers, like Kodak, are developing some excellent digital cameras.

Many choices

With lower-priced, higher-quality digital cameras exploding onto the scene, there are more choices and more options. That can make a final decision hard, particularly if you run into a computer-savvy non-photographer salesperson. They may know computers but might not really have a clue as to what they can and can't do photographically.

The bottom line is that the new digital cameras truly are fun. They offer some new ways of of taking a picture sometimes not even possible with traditional means. Don't look at them as replacing traditional cameras, but as exciting new ways of seeing and sharing the world that is important to you.

"Everyone has the potential of making custom prints at home at a fraction of the cost of a lab print."

CHAPTER 4
LIKE A DARKROOM ON YOUR DESK

Control of the image is key to making photographs do what you want them to do. For example, if a scene should be light or dark, you need to know how to control exposure with the camera. If motion should be blurred or sharp, you need to control shutter speed.

Not that long ago, most photographers considered image control after the photo was taken a key part of the black-and-white photographic process. As color photography began to dominate, many people started to think control of the color image stopped once the picture was taken simply because it was not easy to do. Even though a photo could be made lighter or darker in the print, people rarely did even that with color, and slides could not be changed at all, other than by making duplicates (but that resulted in loss of image quality).

The computer brings back control over the image. You can now carefully tune the color balance or adjust dark and light areas without changing the color in those areas. You can precisely crop, change focus and more. Everyone has the potential of making custom prints at home at a fraction of the cost of a lab print. They can also make corrections to the image as they go, without having to make repeat trips to the lab.

Software choices

Choosing the right image processing software takes some thought as there is no one program that is best for everyone. You need to carefully examine what a program can do for you, what its interface looks like, how much RAM it needs, and how its personality fits you. Software definitely has personality in the way

the designers have chosen the tools, the layout of the screen and the features available. Try to see the program in use or get whatever information you can from computer magazines, brochures, ads, box labels, *et cetera*. Often you can download a preview copy from the manufacturer's website.

You can't always go by supposedly objective reviews (no matter how well-meaning the intent is). Too often, reviewers base their evaluations on very subjective impressions of how a program works compared to a program they are used to rather than what the new software actually does. A review by an art director or graphic artist will give a very different impression than one by a photographer, because their needs are different. You may also find that more than one program fits your needs better than trying to get everything in one piece of software. Two or more programs may give you more control and versatility than one.

Conflicts and lockups

As you use a variety of software, you may get conflicts. The computer may get confused and lock up. You may also find the machine freezes when you try to use a larger image file. That might be too much work for the available RAM, so as the computer uses the hard drive for help, it gets confused again and locks up.

Be patient. You haven't done anything wrong. Check "Appendix 3" for some ideas on coping with this problem. There are some software programs available to help you identify where the conflict is, such as Helix Nuts and Bolts. Newer operating systems for both Mac and Windows machines promise to do better with conflicts, but anybody who's worked with computers for a while tends to take a skeptical view.

Monitor settings

Before you can work on your photo in the computer, you need to have your monitor, your "display" as Windows calls it, set correctly. You need to set your monitor to at least 800x600 resolution (1024x768 is better) and True Color (millions of colors). You'll find the old standard of 640x480, 256 colors (fine for word processing) extremely frustrating as this setting will not show you what your image really looks like.

Higher settings need more resources from the computer in terms of RAM and processing power. This is why graphics boards (the internal part of your computer that makes your monitor work) have their own RAM (video RAM). More on-board RAM means the card can process the higher resolutions better.

Finally, your monitor has to support the higher resolution and color palette. This is rarely a problem when using the monitor that came with the computer (and installed graphics board), but can be a real challenge if you change the graphics board.

"You'll find the old standard of 640x480, 256 colors (fine for word processing) extremely frustrating..."

(right) You must have at least 800x600 and true color set for your monitor in order to work with photos. If you change your monitor, you will often need a better video card that supports higher display resolutions (display resolution has nothing to do with picture resolution).

(below) A large monitor, such as this 17-inch unit from Princeton, is a great tool to make your image processing easier, but it works best when driven with higher display resolutions.

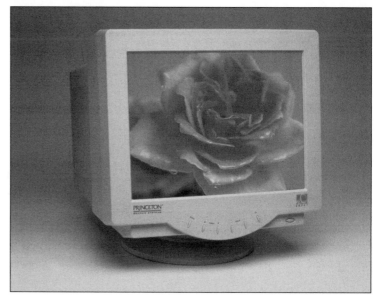

CHAPTER 5
GETTING THE IMAGE RIGHT

When you start to work on an image in the computer, think first on how you want to control it as a photograph. Have an idea of what would improve the image: more color, better contrast, more accurate color, composition, *et cetera*. Then try using the controls described below to make that image sing to your tune.

"Try" is an important word. You can't hurt the image by adjusting it on screen. If you are worried, work on a copy of the original. Experiment by moving the controls to extreme positions just to see what will happen. Then back off the control or just cancel (or reset or undo) what you did and start over. If you do a few things and decide you don't like it, revert to the saved original image and start over again.

This aspect of working with photos on the computer can be exhilarating. Now you can try adjustments and effects and see the results in an instant. You don't have to wait for the chemicals to work (as in the darkroom) or the processor to get done (another trip to the lab) to see if your changes have the right effect.

"Very often, an image can be improved by cutting out the distracting elements..."

Cropping

Cropping an image is basic to photography. Very often, an image can be improved by cutting out the distracting elements: the foot that snuck in at the edge, the excess foreground, *et cetera*. It is often hard to see what a crop will do to an image until you actually do it. On the computer screen, you can

Cropping can strengthen composition and create dramatic effect, as in this scene from Bonaire.

compare the original to the cropped image using the undo/redo command). It is easy to try another crop if it isn't quite right, without wasting photo paper or much time.

With that said, don't use the computer as an excuse for poor work when taking the actual image, because you can "fix it in the computer." You want to get the best image possible when you actually shoot the photo and use every bit of the image area of the negative or slide that you can. That will ensure you get the absolutely best image quality possible for your photo.

Cropping can make a good image better. Cropping can also let you change the shape of an image, everything from long and narrow to square to circles to hearts or any shape you can imagine.

Brightness and contrast

Nearly every software program that works with images has a brightness/contrast control. Usually, they come up together as one tool. This linkage is important, because as you change one control, you usually have to change the other, too, to get the best results. Brightness and contrast are so intuitive, so "photographic", that many photos can be adjusted with these alone. But because they are such intuitive and highly subjective controls, there are no easy rules that can be followed.

It often helps to make the brightness change first. Bring the control up or down until the important details become more visible (assuming they are in the image — you can't get detail that is not in the scan). Then adjust the contrast until the blacks come

back. Watch your highlights so the detail in those areas doesn't get washed out, either.

Contrast is greatly affected by how the image comes out of the computer. If you print on an inkjet printer, for example, you may choose to print on a number of different paper types. Paper can change the appearance of the final image, so you have to do adjustments on screen to get the best prints.

Adjusting contrast and brightness can bring some life to a gray day.

Sometimes, you can get some very interesting effects by using extreme contrast settings. Just push the control high (this will often make the image look very harsh), then bring up the brightness until the image has a dramatic look that you like. This technique drops out middle tones and makes the photo very starkly graphic.

Color correction

The world is made up of an infinite number of colors. Our eyes adapt to different colors of light, making whites look white, grays gray and blacks black. Film can't do that and will pick up color casts we don't always like. On film, all colors have to be represented by the mixture of three or four colors (the dye layers of color film or the RGB and CMYK settings of the computer). This means that the film can have a shift in color compared to what our eyes saw and color balance may be a problem.

Color balance in an RGB system (red/green/blue — the typical setup of most computers) is adjusted with three controls: cyan to red, magenta to green, yellow to blue. Some programs even allow you to adjust these colors in shadows, mid-tones and highlights separately.

Your best bet is to decide if there is an overall color cast first. Then go to that color and adjust the slider (usually they are

sliders) toward the other color, away from the overall color. This may give you all the correction you need. If not, try the other color sliders.

Often it helps to do an extreme change. This will quickly tell you if you are on the right path or not, so you can go back and adjust more finely. Extreme positions don't always look "extreme" because color correction is a subtle tool and doesn't make major color changes.

You can use this tool for creative effect. Make a sunset richer by increasing the red and yellow positions. Richen the green of a landscape by pushing the green up and adding in more cyan (as it is on the same slider, it takes out the red).

The existing light gave excellent character to the scene, but to obtain the best image, it needed some color and contrast correction.

Some programs allow you to actually change the amount of color in a color channel. As you work on an RGB image, you have R-red, G-green and B-blue channels. If you go into a particular channel, say the red, you can make it stronger or weaker to adjust the overall color of the image.

Color saturation

Color saturation refers to the vividness of a color — how red the red is, how blue the blue is and so on. This is another key area of color control that you want to deal with early on in an image. Saturation is affected by the film you shot with, the scanner used to capture the image, the type of digital camera (and its chip) employed, and so on. It is also affected by the colors and tones actually in your photograph. A picture filled with bright colors looks more saturated than one taken on a foggy, muted color day. A photo with black shadows behind a bright color can make that color seem even more vivid.

Once you have the image in the computer, you can intensify or de-intensify the colors. In recent years, we've seen a trend toward bold, highly-saturated colors in movies, in commercials, in magazines and so on. Film manufacturers have worked toward getting brighter colors in their films. People expect bright colors, and you can get them digitally.

Still, not everything looks great with bright colors. A gentle forest scene, a romantic portrait, a hard-edged news photo, these sorts of images might not look best with highly saturated colors. Also, an inkjet or dye-sub printer may even intensify colors, so you need to be careful you don't add too much saturation to an image, only to have the printer add more so the colors become garish.

Almost all programs offer an overall color saturation tool. You simply select it and start adjusting, either adding or subtracting vividness, until the colors look the way you want them to look. Some programs offer additional control by allowing you to adjust a particular color's saturation. This can be very helpful to compensate for a film's bias, for exposure problems (sometimes not all colors will be exposed the same) and for creative control (you can saturate a red flower without affecting the green leaves around it, for example).

Sharpness

The sharpening tools are not substitutes for good photo technique. Dispite what you may have seen in detective or spy movies, they won't make an out-of-focus image sharp, and they cannot correct for camera movement. An important basic use for the sharpness tool is to sharpen scans. Most scans need a little sharpening to look their best.

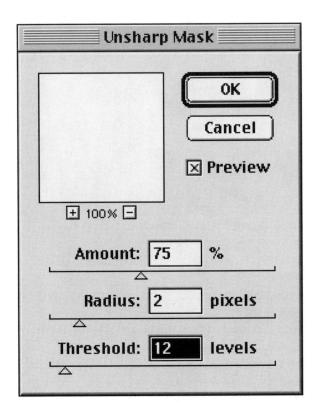

Be careful not to over-sharpen. Sharpening works by looking at contrast differences and then enhancing them. Too much of this enhancement and the photo begins to look "edgy" (edges get halation). Over-sharpening also increases the appearance of grain in the photo. Both the edgy look and grain can be used for creative effects if done deliberately. It is usually best to sharpen gradually using several applications of lower levels of sharpness rather than trying to do it all at once.

Unsharp mask is a very useful sharpening tool, in spite of its name. The term actually comes from the printing industry where they used to increase sharpness on printing plates by using a special masking process. Unsharp mask offers three settings to adjust for sharpening: amount, radius and threshold. Try using the amount setting in the to middle range, radius at 1-2 and threshold at 10-15. The amount is kept below maximum for the reasons noted above — do the sharpening in steps rather than all at once. Radius refers to how wide an area the software checks as it makes its sharpening decisions. You want the program to look close to

edges (unless, again, you are after a special effect). Finally, threshold refers to the point at which the program notices differences. A low threshold number will sometimes make an image look sharper, but it will also affect small differences in the image and can increase grain and make smooth areas look like they have texture that they really don't have.

Sharpening with the unsharp mask tool is highly subjective. Here the threshold was too low and the radius too high for normal sharpening which caused the edge around the shirt and the grainy feel. However, for creative effect, you may want to experiment with oversharpening.

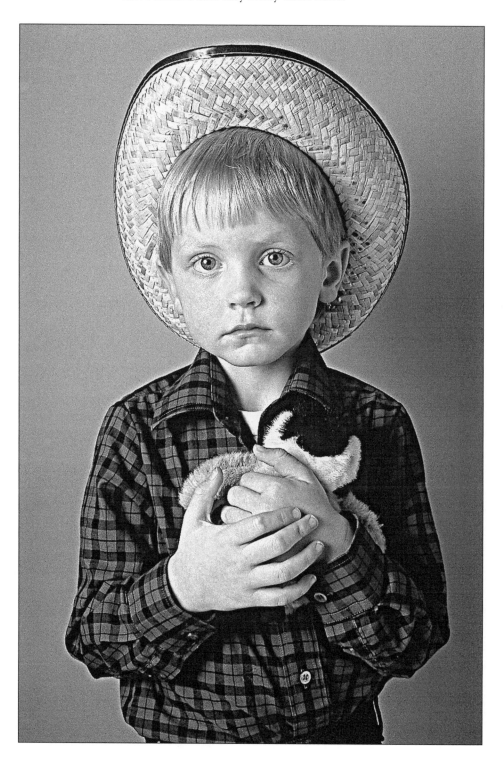

CHAPTER 6
MAKING THE IMAGE EVEN BETTER

In the past, making a custom print of an image was time consuming and expensive, but the skill of a fine printer would make magic happen to a print in very defined areas. This was especially true of black-and-white photography such as that done by W. Eugene Smith or Ansel Adams. They would take days and even years to perfect a print (Adams talked in his books about changing the interpretation of a negative years after the original was shot). The computer alters all of this. Now you can make a highly customized print, right from your desktop, and once you make it right, you can repeat the print again and again (replicating results is difficult to do with traditional darkroom techniques).

Cloning to correct problems

Cloning is the process of copying one part of a picture to another. What this tool does is grab a small piece of the image and move an exact copy directly to another place in the picture. Even if your program has no cloning tool, you can duplicate the effect by copying tiny circles in the image, then pasting them elsewhere into the problem spot.

This tool is extremely valuable to correct flaws in an image caused by dust and scratches and is a necessity for restoring damaged photos. It will allow you to fill in cracks and holes in an image, as well as to cover up scratches. Cloning also fixes visual garbage. How often have you taken a photo and found something alien growing from your subject's head? The cloning tool

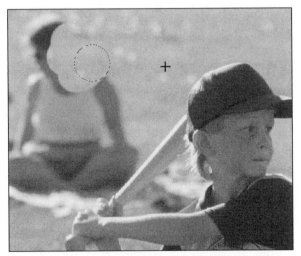

The cloning tool copies small parts of an image and puts them over other parts.

lets you remove that accidental distraction, so the background looks the way you saw it when you took the picture.

Think of cloning as your tool to remove parts of an image you don't want. Anything that does not belong in the photo can be removed.

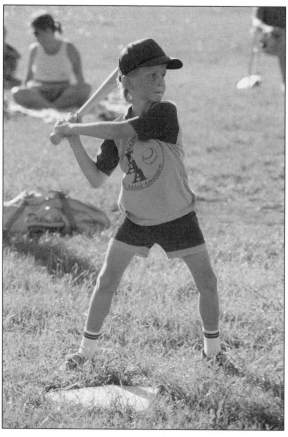

The subject of this photo is the young boy. At the best shooting angle, there were distractions that could not be moved. The cloning tool can remove the problems to better reveal the subject.

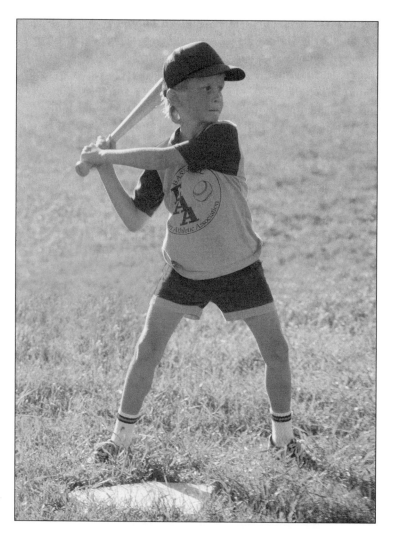

Some cloning tips:

1. If you can adjust the tool, first use a soft-edge, small to moderate-sized cloning area. Soft edges make the cloning blend better. Hard-edges work well when you are trying to fix an area close to a sharp edge on your subject.

2. Magnify your image on the screen so you can see details more clearly.

3. Experiment with your clone-from point (the place where your cloning begins from). Sometimes a very

CLONING TIPS:

1. Use a soft edge.

2. Magnify the image on screen.

3. Vary the clone point.

4. Undo mistakes immediately.

5. Use continuous and spot cloning.

6. Select an area to include or exclude cloning.

little change in location one way or another will make a big difference in how well the cloning works.

4. Use your "undo" command as soon as you see something go wrong. The key command for this is control or command-Z for most software, but you can also find 'undo' on the menu under edit.

5. Try both continuous and spot methods of cloning. With the continuous technique, you move the mouse or other pointing/drawing device as you clone. With the spot method, you move the tool first, then make the clone, one spot at a time.

6. Make a selection (explained below) to confine cloning to a specific area. This works especially well when you need to clean up something right next to your subject. Select the background right up to the edge of a face, for example, and you can now clone right up to that edge without affecting the face.

One problem with film is that it can get dirty. The cloning tool lets you remove dirt and fix scratches or change composition. Here the image was tidied up and power lines were removed from the sky.

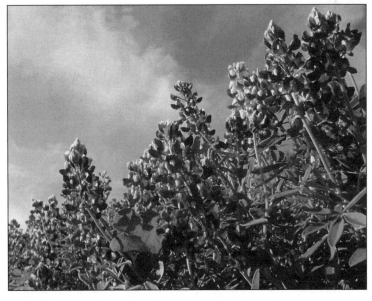

Selections

Selecting areas within an image is key to most higher levels of image control. Selections allow you to limit your changes to a "selected" or isolated area of the image. A selection allows you to modify that area, copy it, delete it or move it.

To make your selection, you outline, paint or mask a specific area you want to change. This area can be as small or large as you want. By confining your changes to this carefully defined area of the photo, you achieve customization that was nearly impossible before computers.

Selections are made in a variety of ways, depending on the software program. Most programs offer standard shapes, such as rectangles and circles, but the most useful selection tools for photographers are those that allow you to outline an irregular area (which most real-life subjects tend to have). These include free-hand tracing (also called a lasso), outlining, magic wand, polygon and brush/painting tools. You choose and use them based on the shape you need to outline. If you miss part of the area you need to cover, you can add or subtract from the selection, or if you really missed, just remove the selection (command or control-D for many applications) and start over.

Some programs call selections masks or will make masks from selections. All this means is that your selection will mask out part of the image so that when an action is taken on the image, nothing happens to the masked area. You invert the mask to change where you can affect the image and where you can't.

Selecting an area of the photo allows you to precisely control and limit your adjustments to just the area selected.

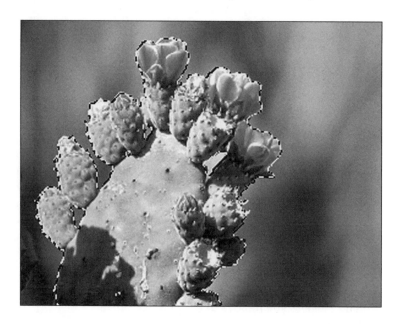

Here are some hints that can make the work a little easier:

1. Magnify your view so the edge you are following is more visible.

2. Use a program with a smart edging feature, which will help you to more easily follow the edges of two the areas you want.

3. Make a selection in 2 steps. Make your first pass quickly, then correct the selection when done.

4. Select in segments. Don't try to capture the entire background at once, for example. Get one piece selected, then add to the selection.

SELECTION TIPS:

1. Magnify the screen view.

2. Use smart edging.

3. Make selections in steps.

4. Select in segments.

5. Use inverted selections to help capture difficult areas quickly.

6. Use a combination of selection tools.

7. Use feathering to soften selection edges.

5. For difficult areas, try selecting an easy area nearby, then inverting your selection. For example, outlining a person's head can take a lot of time, but if that subject is against a plain background (such as the sky), you can often select the sky with a magic wand tool, then invert the selection to the person.

6. Use a combination of selection tools, e.g., use a rectangle to capture most of the sky, then use the "add-to" function of the tracing tool to bring in the rest of the sky to the edges of the mountain.

7. Consider the feather choice if your software has it. Often a selection looks better if it blends a little at the edges. The feather tool controls how much this blending occurs and can help a changed selection to better fit the scene.

The magic wand tool allows you to click on an area, then have the computer figure out where the area ends, based on similar color and/or brightness. What it looks for are connecting colors and/or tones that are the same as the one you clicked on to start. Some programs allow you to adjust the sensitivity of the magic wand so that it looks for more or less similar colors/tones compared to the place you started. The magic wand is best for selecting very similar toned or colored areas as it only looks for similarities, such as the sky or a solid color shirt. It has a terrible time with texture or highly patterned parts of an image. Some plug-ins for image processing programs offer even more automated, yet excellent, software enhancements for making better selections.

Selective focus on the cactus helps clarify the subject, but selecting the cactus and adjusting it can separate it better from the background.

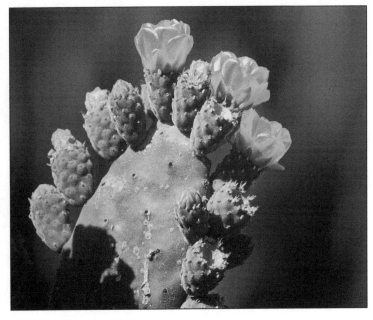

"The computer now offers us three ways to alter tonality..."

Lighter or darker by area

In the traditional darkroom, photographers spent much time carefully selecting paper contrast, then dodging or burning in an image to compensate for the limitations film has in handling the great range of brightness found in the world. Dodging made part of the print lighter, burning in made it darker.

The computer now offers us three ways to alter tonality: with dodge/burn tools, with selections and with a combination of the two. For any method, first look at the image for areas that appear too bright or too dark. Bright areas away from the subject are distracting and tend to pull the eye away from the subject. Many black-and-white darkroom workers used to darken (burn in) the corners of the whole photograph slightly just for this reason. However, dark areas can also be unattractive when you can't see needed detail.

Use the dodge or burn tool gradually. Try it at a low setting (if possible), then gradually lighten or darken your image. If you have trouble with an edge, perhaps you want to lighten someone's hair so they stand out better against the background, make a selection along that edge. This way you can move your tool right to the edge and not go over it, because you will only affect what is in the selection.

Often the too-dark or too-light parts of the image are very distinct and need to be adjusted carefully, so as to not affect adjacent areas. Selecting an area keeps those changes to the selection alone. Start by adjusting its whole brightness/contrast range. This is often enough to do the job. You may need to feather the edge of the selection for better blending or be careful that the edge fits a distinct edge in the photo.

This photo gained its full potential by selecting three areas individually — the foreground rock, background and sky — then adjusting separately.

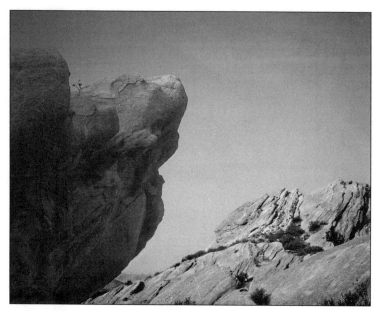

By changing the contrast in one small area of a photo, such as a face, you are changing the "local" contrast (local to a defined area), as compared to the overall contrast of the image. Shadows, for example, are often weak in contrast, especially compared to the sun, so a brighten/contrast adjustment just to a shadowed face makes the face look better.

You can also make the image clearer by adjusting the brightness/contrast of a selected area to better define the composition. You can make specific parts of the subject stand out better against the background by selectively lightening or darkening the background behind the subject.

Combining selections and the dodge/burn tool gives precise control to your darker or lighter areas. This is a great help when you have to make a subject stand out from a background. Select a snowy mountain top, for example, then burn in the top edge to set it off against the clouds. The selection lets you very precisely limit where that "burning in" occurs.

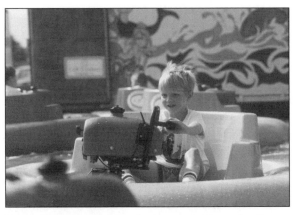

Very often a photo can be improved by selecting the background, then adjusting it so it sets off the subject.

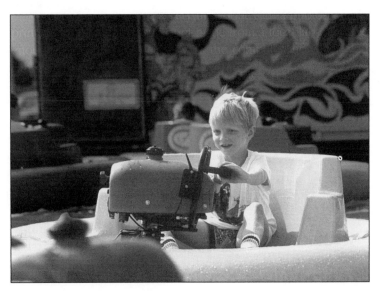

Selective color adjustment

One reason many photographers have never pursued color darkroom work is because of the problems of color shifting. As you increase or decrease overall exposure, color balance can change. As you dodge or burn areas, colors can shift. The computer allows us to correct this, and it opens up new possibilities with subjects in varied light conditions. We don't have to accept too-blue shadows or other small-area color problems.

There are two main adjustments to color to be made that can be found on most software: color balance and saturation. These don't, however, exist in isolation from the rest of the changes. For example, brightness/contrast adjustments will usually also affect

"...sometimes the combinations can be surprising."

color. Selecting the problem area is again key to this work. Decide where your color challenges are, then take them one at a time.

Use color balance to affect areas that have a color cast, like too much blue in the shadows, too much green in a fluorescent-lit area. Adjust the sliders until you see the colors you want. This is a highly interactive process as you compare the changes in your selected area to the rest of the image. You can go crazy and make your area entirely different than other parts of the photo, but usually you want it to blend in.

Adjust away from the colors you want to reduce. For example, move the slider away from red, toward green, if you want less red. This is not a precise science. Try things. Make extreme adjustments to see if you are going in the right direction. Often a combination of color changes will give the right look to your selection, and sometimes the combinations can be surprising. With experience, you will go to the right adjustments faster, but you will frequently need to experiment to find the combination that works for each unique photo.

Saturation is a powerful color adjustment tool. Sometimes, a reduction in saturation will make a problem color disappear with no other changes needed. A good example of this would be with winter snow images. There, the blue cast of a shadow can be important, but sometimes it is too blue. Bringing the saturation down may make the image look better than adjusting color balance.

Increased saturation is most often needed when dealing with weak shadow areas. These areas can be weak because of the light, too much blue or underexposure. Adjust them for the correct brightness and color balance first, then bring up the saturation. This can really help to make skin tones more natural or bring in shaded foreground detail in a landscape shot.

You can also get creative with this technique. Try selecting a subject, inverting the selection so you get everything else in the photo selected (this, in effect, creates a mask over the subject), then adjust the color so the subject stands out more. A little extra blue tone to a background will make a warm subject stand out better and make it look even warmer. Less saturation to the selected area will make the more saturated subject contrast quite nicely with its surroundings. These effects can be done subtly so the result is natural looking or you can go all out for a very dramatic look.

Selective sharpness and unsharpness

One of the best ways of making a subject stand out is to contrast its sharpness with its surroundings. A person in a crowd will immediately be seen by the viewer if he or she is sharp while the rest of the crowd is blurred. A flower will boldly jump out at you if it is sharp in a sea of unsharp color.

The effect works great when you shoot the subject this way with very limited depth of field (large _f_-stops and telephoto lenses work well here). But you can't always do that. By carefully selecting the subject, then inverting the selection, you can now control the sharpness of the surroundings. Begin to blur the surroundings. Gaussian blur works best for most situations, although the other types of blur, from motion to wind, can give great effects with the right image. Watch the change from subject to surrounding sharpness. When the subject stands out appropriately, you've got it.

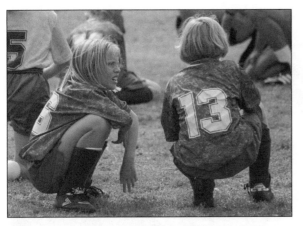

With the background selected and blurred, the girls stand out better emphasizing their connection during the break in the action.

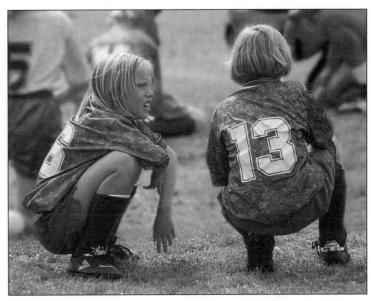

This can be a very useful trick when you need some depth of field for your subject, but don't want so much sharpness in the background. This used to be a catch-22 — if you made the subject as sharp as needed, the background might be too sharp so that it takes away from the subject. For example, let's say a child is holding a birthday present and they are the subject of your shot; both child and present should be sharp. From any angle the cake and ice cream table in the background might prove too distracting. If you go for less depth of field to blur out the background, there is no way you could capture both the kid and the present. This problem can be solved in the computer. Take the photo with enough depth of field to make child and present sharp, then you can select the background (or select child and present first, then invert selection) and blur it out enough to make the subject show up better.

Be careful you don't overdue the sharpening or softening of any selected areas within a photo as the edge between the selected and unselected areas will begin to look weird. If you can, use a feathered selection to blend the edges.

Black-and-white

Black-and-white photography has received a renewed interest in recent years, and you no longer need to own a darkroom. You can do wonderful black-and-white prints from the computer, either from original black-and-white images or from color pictures. This book cannot go into all of the nuances of black-and-white. There are many good black-and-white technique books on the market for that. But almost everything that can be done in the darkroom can be done on the computer faster, easier and with no toxic chemicals.

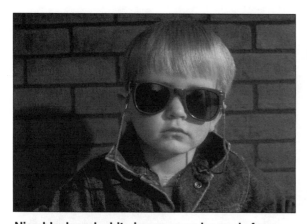

Nice black-and-white images can be made from color, but do more than change the color to grayscale. At least adjust brightness and contrast.

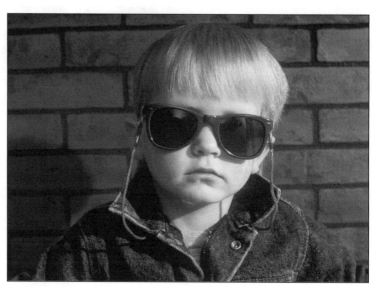

One mistake many people make is to think of black-and-white as simply a photograph without colors (except the obvious, black, white and gray). With that line of thinking, one should be able to take any color image and simply remove its color to make a black-and-white shot. That approach will largely give disappointing results no matter what is done in the computer and send the photographer back to color without really exploring the fascinating aspects of black-and-white.

Whether you are shooting black-and-white or color film to start, you have to look at subjects differently to make the best use of black and white. Colors have to be seen as light or dark areas and no longer as colors. Colors can be very seductive, but very often a colorful, attractive scene does not translate as well to black-and-white if you don't look for certain things. Here are some hints:

BEFORE CHANGING A COLOR
PHOTO TO BLACK & WHITE:

1. Look at highlights and shadows.

2. Look for appropriate contrast.

3. Be sure you have strong black shadows.

4. Expose for the shadows.

5. Use either black-and-white or color print film.

1. *Look at highlights and shadows.* Both of these are the result of how light affects the subject and surroundings. They show up very strongly in black-and-white.

2. *Look for appropriate contrast.* Colors often look great when they are quite different and also when they show softly muted hues — two very different looks for different moods. Yet, when translated to gray tones, these same colors can lose their vibrancy. Look for tonal contrasts (light and dark) that define and separate your subject and its surroundings.

3. *Be sure you have strong black shadows.* Sometimes this isn't appropriate (e.g., a fog), but usually a scene without some strong shadow (even if small) won't look its best in black-and-white.

4. *Expose for the shadows.* Give your subject enough exposure that shadow detail shows up (even if dark). Be very careful of underexposure.

5. *Use negative film,* either black-and-white or color print film. Slides can be converted to black-and-white, but it is harder to get the most from the image.

If you are serious about black-and-white, shoot black-and-white film. This will quickly teach you to deal with the challenges of translating colors into tones of gray. You don't need a darkroom to do this. Shoot Ilford's XP-2 or Kodak's T400 CN black-and-white films. These films are based on color technologies and can be processed by any color mini-lab. tell them to treat it like color film. Prints should be printed as neutral as possible, but they can have a tone to them (selenium-toned or sepia-toned). You will use those prints as "proofs" for your negatives, then have the negatives scanned into your system (or put on a Photo CD or Flash-Pix CD). You can also scan the prints.

Everything mentioned in the last chapter and this chapter will help make your black-and-white photos better. However, for best results as you first start working with such images in the computer, you might consider how important brightness and contrast are to the final image. Most black-and-white printers will spend a lot of time getting the combination of exposure, contrast and paper grades just right. Now you can see changes in these areas made real time on your monitor.

Steps to better photos

The following order of adjustments works, but change it to make it most appropriate to your way of working.

1. Sharpen using the unsharp mask, as most scanned images need a little sharpening.

2. Crop to remove unwanted elements from the photo and reduce its "footprint" (the digital size of the image).

STEPS TO BETTER PHOTOS:

1. Use the unsharp mask.

2. Crop the picture.

3. Clean the image.

4. Remove unwanted color casts.

5. Adjust general brightness and contrast.

6. Make selective changes in brightness and contrast.

7. Change area focus.

8. Make a final crop to focus the image on the subject.

3. Clean up the image. Look for dust or scratches to remove from the photo and take them out.

4. Remove unwanted color casts.

5. Adjust brightness and contrast.

6. Look for areas to selectively change contrast or brightness. Burn in the corners, dodge dark faces, select specific bright or dark areas and adjust their brightness and contrast within. Tone down distracting bright areas, open up too dark shadows. Do whatever you need to do to make the image come closer to what you saw.

7. Change out-of-focus areas as needed.

8. Make final crop to enhance composition and really focus the image on the subject and its relationship to the surroundings.

The original shot of this bit of soccer action held some interesting details, but they needed better emphasis. Cropping, use of the unsharp mask, and adjustments to color and contrast make the action stronger and easier to see.

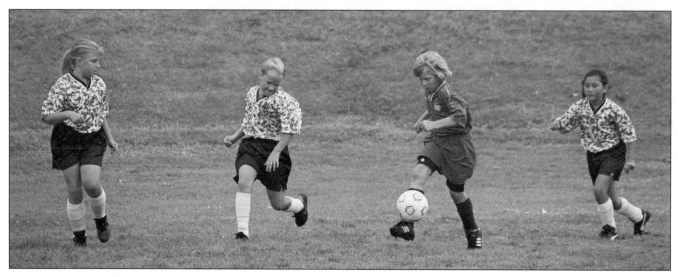

CHAPTER 7
CREATIVE ENHANCEMENT

When darkrooms were popular, photographers experimented with many ways of interpreting their image. They used high-contrast, solarization, texture screens, multiple printing and more. When people started shooting mostly color, these approaches were often forgotten since color was hard to print at home. The computer's capabilities offer photographers new opportunities and new possibilities to make fresh images and go beyond the expected. Your ideas of what a photo can be are limited only by your imagination.

Turn a daylight scene into a night shot. Use the brightness/contrast and color correction tools, and maybe even add a moon.

Changing colors

Once you start adjusting a photo's colors, you will quickly discover that you can do much more than simply getting rid of color casts. Being able to work more deeply on colors can greatly enrich the possibilities of any photographer's images. Here are some things you can do:

1. Change the hue. The hue is the actual color of something. An overall adjustment can be interesting, but often the most interesting work can be done by selecting a part of the image (such as the sky) and adjusting it alone (maybe making it look more like a sunset).

2. Blend a color with the image. Mixing blue into a day scene can make it look like night. Create a pleasant background for a photo; for example, a yellow blend placed behind a child holding sunflowers enhances the image. In programs that use layers, use the layers to build one element on another. For other programs, you may be able to add a color onto the image or copy a solid color and paste it over your original (blending or dissolving it).

3. Combine black-and-white and color. A small area of color will stand out boldly from the rest of a black-and-white photo, almost as if in a spotlight. A good way of doing this is to select the area you want in color, invert the selection so the rest of the photo is selected, and remove the color.

4. Vary the color saturation. When a color is saturated, it tends to stand out from less saturated colors. Use this effect to make parts of your image come forward or recede. Select areas one at a time and saturate or desaturate as needed. For example, a flower in a garden might show up better when the background behind it is desaturated.

Cloning to change the image

Cloning can let you dramatically change an image, even to the point of fantasy. You can add trees to the background for a very simple addition to the image, or you can duplicate a person again and again for a special effect. Some ideas:

1. Fill in gaps. Often you can't get the right angle to a scene and there is an unpleasant gap in the middle that can't be changed. Try cloning trees nearby to fill in the gap. Trees and bushes are a natural way to fill gaps.

SOME OPTIONS FOR CLONING:

1. Fill in gaps.

2. Change the skyline.

3. Bring a landscape back to its original form.

4. Duplicate something in one photo into another.

2. Change the skyline. Remove a building or duplicate a building to give a skyline a new look.

3. Bring a landscape back to its original form. Remove the houses and other visual garbage that distract from the real landscape underneath it all. Show what your area once looked like before "civilization."

4. Duplicate something in one photo into another. For example, you could add a distant relative to a family photo that could not include her. Taking something from one photo to another works best with a program that allows you to open both images at once, although it can be done on a single image. For the latter, you need to copy the part of the image you want to clone from, then open your new image and add "canvas" or active work space to one side of the photo. Paste the copy into that work space, then clone from there. Crop the added work area off later.

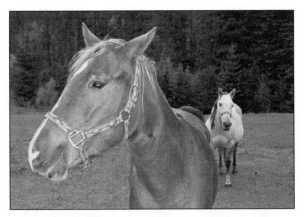

Cloning is possible for more than sheep in order to creatively change an image.

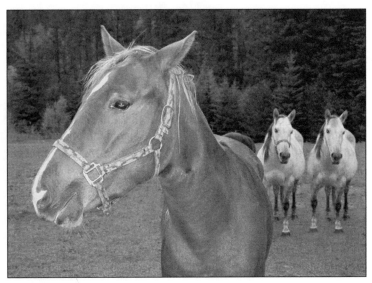

Filters and effects

Many image processing programs have special filters to change the look of an image. They can be applied to the whole image or confined to a selected area. The following sample filters and effects will give you an idea of what's available:

Colors — some programs have filters to make a photo have a sepia tone or to correct for color imbalances

Distorting — there are a number of filters that can distort an image in different ways

Filters in the image processing software give completely different looks to a photo. The top photo is the original. Embossing (right) gives an interesting three-dimensional look to the photo.

Embossing — gives an embossed look to your shot

Find edges makes interesting sketch effects from normal images by selecting and darkening the high contrast areas.

Find edges — makes image look sort of like a drawing by emphasizing contrasting edges

A LIST OF FILTER TYPES:

1. Color
2. Distort
3. Emboss
4. Find edges
5. Mosaic
6. Mezzotint
7. Noise
8. Page curl
9. Sphere
10. Twirl
11. Wind

Mosaic — breaks up a photo into tiles so it looks like a mosaic

Mezzotint — a grain-like pattern applied to the image. The filter actually is based on a process from the printing (publishing) industry originally used to give photos a distinct look when printed on poorer quality paper.

Noise adds a grainy, impressionistic look to photo (this filter is also very important for matching image textures when compositing).

Noise — adds a grainy look (also helps you match images when you combine them)

Glow by combining the original with an image processed by the "glow" filter, a soft, ethereal effect results.

59

Page curl — looks like the edge of the picture is curling up

Sphere — makes an image look spherical

Twirling, swirling — filters that spin the image in spiral patterns (good for backgrounds that you add a subject to)

A number of filters distort the image for dramatic (and sometimes humorous) effects. This is the result of using the twirl filter.

Wind — makes the picture look like the wind has smeared everything in a selected direction (most useful when applied to a part of the subject)

There are a lot of other filters and effects available with various programs. The only way to really know what a filter will do to any given image is to try them. Use a small photo file (say 1MB or so) to try out the filters quickly. Some effects are very memory intensive, so by using a small file, you won't have to wait too long for the effect to work. Remember that filters are often quite effective used on part of the photo rather than all of it. Once you gain experience with what they do, you will be better able to achieve the results you expect.

Morphing, Warping, Panoramics and More

Morphing became popular a few years ago with the movie, "Terminator 2". Morphing allows you to take two subjects and knit them together so it looks like they are truly one new, strange

subject. Morphing programs lets you link specific locations in two photos, then the software combines them in degrees. This can be a great way to combine a child with an animal, for example, by linking them at the eyes and nose. You'll find morphing features in some image processing programs, but you'll usually find more control in stand-alone morphing programs.

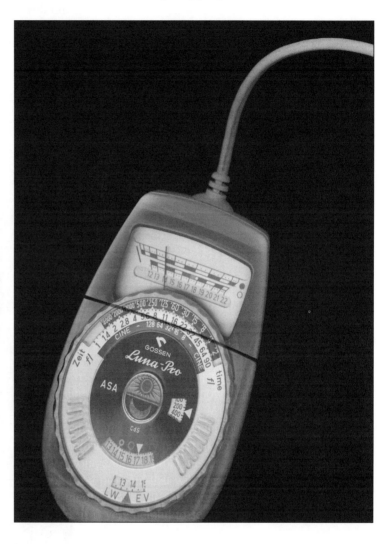

By morphing two images together, you can make something entirely new for a highly creative and high impact image.

Panoramic programs work like morphing programs. They let you link the same areas in overlapping photos, then the software brings them together (morphs the overlap) for a seamless panoramic image. In the past, many photographers shot panoramic (wide) photos by taking one picture, turning the camera to one side in order to capture more of the scene and continuing this until the scene was covered.

Once the prints came back from the processor, they could be lined up for a panoramic impression of the scene. Problem was, the prints might be a little off in composition, brightness or color, so the effect was not perfect. Panoramic programs actually com-

pensate for these variations. All you have to do is be sure the overlapping parts of the photos have distinctive elements in them and the software does the rest. It lines things up, corrects minor problems along the edge, adjusts color and brightness and more. You can actually shoot a 360° panoramic this way.

Some panoramic programs even let you build an image up and down, while at the same time combining photos for the wide effect. This allows you to make a digital camera, for example, perform as if it had a very wide-angle lens. You shoot the scene as a mosaic, maybe four shots wide and three shots high (all shots with some overlap). The software then puts a single wide-angle photo together from the individual shots (a photo that also has higher resolution than the typical digital camera because you are adding shots together).

Panoramic software gives you the opportunity to stitch together images wider than your lens can capture alone. The four small images were combined in the computer to make a large, wide-angle view of the harbor that would have been impossible even with a very wide lens.

CHAPTER 8
COMPOSITING

Compositing means taking an image, or part of an image, from one photo and putting it into another. The technique, however, is not limited to making fictional images or fanciful creations. It can be very important to traditional imagery, too. For example: a piece of sky gets a nasty gouge in the original and there is not enough sky around it to easily clone out the problem. If you have taken two shots of the scene, you can cut a piece of sky out of the undamaged image that maybe isn't as good compositionally and

Combining, or compositing, photos can let you give an entirely different background for the subject.

The original sky was okay, but the clouds became more dramatic a little farther down the trail. The composited image allowed the shot to more faithfully reflect the conditions of the day.

paste it over the defect in the original. You haven't changed the world, only corrected a serious defect in the photo. Or maybe you have some great shots of kids playing in front of a wall. Unfortunately, the best shot of the kids has a nasty bit of graffiti showing on the wall. You can take a section of cleaner wall from another part of the image or another shot and cover the offensive words.

Groups are always a problem, and a problem that can be helped with compositing. How do you get the timing of the shutter to catch the best expressions of every person? You can now choose the best composition of the group, then cut out a person's better expression in another shot to replace his or her closed-eye look in the best shot. This helps you make the group look its best.

Another problem is shooting a big landscape with a wide range of brightness from the fluffy clouds in the sky to the shaded stream in the canyon below. Film cannot handle this tonal range and will not show the detail you can see with your eye. However, you can shoot two photos, one exposed for the clouds and sky, one for the canyon, then bring them together in the computer (composite them) for an image much closer to the reality of the world as we see it.

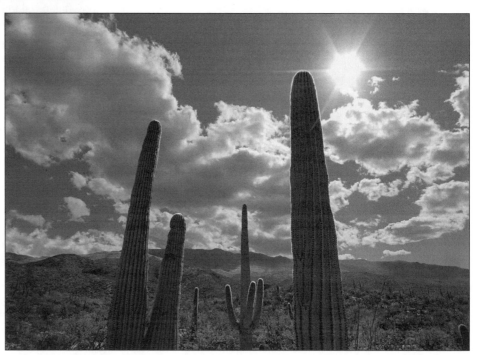

New images

With the computer, you can add almost anything to an image or part of that image. One of the best uses of this idea is to add a

new background to your subject. For instance, you have a great shot of grandfather sitting on his favorite lawn chair. Unfortunately, there is part of an RV, a coil of hose and two squirrely kids in the background. You can cut out the man, then paste him into any background you want, from the realistic (a better composed lawn) to the stylistic (a background you've made by swirling flowers in your image processing program).

Another "background" idea is sky. The sky doesn't always look as good as we'd like when we are ready to start taking pictures. You can quite easily select the sky, then paste a better sky into it. You simply find the sky from a better exposure or another photo, select it, copy it, then paste it into the selected sky of the first photo. Be careful that the sky matches the other shot in terms of the light and contrast. In other words, don't put a sunset behind a portrait of someone shot in midday — it will never look right.

A nice portrait gets better with the addition of a new background by compositing an out-of-focus scene behind the subject. Some added softening along the edges adds emphasis to the face.

Adding images together can help you communicate something important about your subject. You shoot a nice overall scenic

image of the mountains in Rocky Mountain National park. You also shoot some of the great wildflowers there. But you can't get the two subjects together in one shot. In the computer, you can cut out the flowers and composite them with the mountains for a shot that says it all about wildflowers up high.

This process is similar for a family who is scattered across the country. A group portrait is made of as many as possible, leaving room for the rest, then the others are photographed in their area, shot with the same light and a plain background. The long-distance people are then cut out of their photo and composited into the larger group.

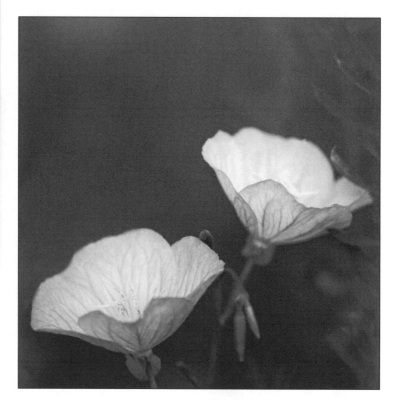

Some photos are built from picture elements you shoot specifically with the end idea in mind (next page). By shooting the girl against a single colored background, cutting her out is easier.

The final composite brings all of the elements together. A little lightening around the edges of the fairy adds a glowing effect. It is important that the picture elements for such a photo all have a similar quality of light (all softly diffused, here).

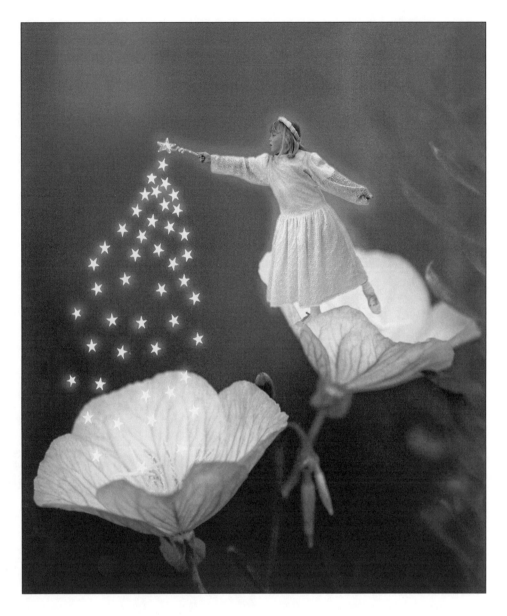

Of course, you can keep going with this and get into some wild effects. You can actually shoot a baby on the floor, then shoot a street from the same angle, and put the baby crawling on the street. Or a kid doing tricks on a horse (photograph them in the same light, but in two separate photos). Or a person looking face to face with a lion.

Tips on making the best composites:

1. Plan ahead when you can. Shoot different elements of your final shot in the same light. It is especially important to match the contrast and direction of the light.

2. Look for interesting elements as you shoot. Think about a scene for its background possibilities or a subject as it might fit a unique background.

3. Look for ways to isolate your subject against a simple background to make it easier to cut out. It often helps to shoot a picture element against a solid background that contrasts in color and tone with the subject.

4. Make your cutouts carefully. The edges are very important. Be sure you are not including excess stuff that will make your cut-out subject look odd.

5. Be sure the main part/background of your new photo is adjusted so it looks its best before adding any new elements.

This composite captures a real event of a bee circling flowers, but such an event is nearly impossible to photograph in a traditional way. The bee fly is so fast it is hard enough to capture it at all, let alone with a good composition, too. The flowers are shot at the same time, from the same position (to match the light), and composited with the bee.

TIPS ON MAKING THE BEST COMPOSITES:

1. Plan ahead.

2. Use interesting elements.

3. Isolate your subject.

4. Make cut-outs carefully.

5. Adjust elements before adding them.

6. Adjust the combined work.

7. Add shadows.

8. Clean up edges.

6. Carefully tune brightness/contrast, sharpness, color balance, color saturation and grain (noise) for the combination to work. If a picture element is much brighter or darker than the background, or much different in contrast, it will stand out worse than the proverbial sore thumb. Sharpness is often not about making the new element sharper, but de-sharpening it to fit its new location (a low setting of Guassian blur, in those programs that have it, is a good place to start). Color casts will also give a composite away, so work to match color balance. While color balance looks obvious, color saturation is often missed. It, too, must match throughout the new image unless you are going for a special effect. Without some grain, a pasted element can look out of place. Add grain with a noise filter.

7. Add shadows. Not every composited element needs a shadow, but often they do to make the composite look real. Paint or airbrush a light amount of darkness under or beside the object. Try to match the color balance of existing shadows (sampling one if you can). You can also add shadows by copying your cutout, filling it with the appropriate blackness, feathering the edge and adding it to the picture, beside the subject. Such a shadow will usually need to be laid down and distorted slightly to make it look real.

8. Clean up your edges. The edges of a composite are always a challenge and can destroy the effect you are after. Sometimes they need to be feathered, blended, smudged or cloned to finish the cleanup.

CHAPTER 9

MAKING GREAT PRINTS AND MORE

Making a nice photo in your computer is fine, but if you can't get it out of the computer, what good is it? Just a few years ago, you would have had to put a lot of money and effort into getting a good print from a digital file. That has drastically changed. Truly photographic prints are an everyday possibility from inexpensive inkjet printers. These prints often look better than what you used to get from your local processor. In addition, big prints, prints on different media, waterproof prints and more are now possible. You don't even have to own all of the printing equipment available today in order to get better prints. Many minilabs and service bureaus, realizing that their market is changing, have added digital output as a part of their services.

Inkjet printers

It really is hard to believe that inkjet printers used to be cheap, second-class choices for quality prints. Every printer manufacturer today has true photographic-quality printers available that produce truly stunning prints. But getting a good print is not simply a matter of buying the right printer. Here are some things to remember:

Image quality — this is highly subjective, just like picking a television set. Color palettes are different — some printers make images more saturated, others make prints more

natural looking, some favor certain colors, while others favor entirely different colors. What is best is not an arbitrary right or wrong decision. You need to go to the store and look at the prints and see how you like them, how they fit with your personal preferences.

Paper — What paper does the printer need? What can it use?

Cost — How much does the ink cost, the paper cost? How much per print will this cost you?

Getting the best results from inkjet printers:

1. Choose the right paper. Nearly all printers give their best prints with special photographic-quality, glossy papers. Inks are absorbed differently into different papers, ranging from high absorption in an inexpensive paper to minimal absorption in a high-priced glossy paper. Inks will also be absorbed at different rates so that colors can change with different papers, even though the printer is the same. The whiteness of a paper will influence how brilliant and bright the print is. Also, consider paper weight, as too flimsy a paper will get damaged easily.

2. Choose the right resolution. Generally, you want a resolution of 300 dpi at the desired print size for a high-quality print. The printer's resolution is an indication of how it lays down ink, not how it deals with the image resolution. Too low a resolution and images will look muddy, grainy, less sharp and have less color when printed. Too high a resolution can actually decrease print sharpness, as well.

3. Adjust the image for the best print. To make the best photographic print from an inkjet printer, you often need to make some adjustments in color and brightness from what you see on the monitor before you make the print. A test print will help you know the adjustments needed. Once you know the color and brightness adjustments needed, write down these necessary corrections to the image so you know what needs to be done when you print. Make your initial test prints on lower-priced, but still high-quality inkjet paper so you have a good idea how the print will look.

TO GET THE BEST RESULTS FROM AN INKJET PRINTER:
1. Choose the right paper.
2. Choose the right resolution.
3. Adjust the image for the best print.

Dye-sublimation printers

Dye-sublimation printers used to be very expensive and the only way to get true-photo quality prints from digital files. Neither of these are true anymore, but they are still more expensive than inkjet printers and still offer very high image quality. Dye-sub

A Fargo dye-sublimation printer.

prints, as they are called, are very bright and vibrant, have good fade resistance and feel like a traditional photographic print.

Unlike the dot-based image of an inkjet printer, the dye-sublimation process gives a continuous tone image, just like a traditional print. Prints are made by passing a special paper under three or four separate colors on a ribbon (or each color can have its own ribbon). A thermal head heats the ribbons so that the color dyes "sublimate" or turn into a gas that is laid onto the paper.

Dye-sub print materials are more expensive than inkjet supplies. Also, some people have commented on another challenge — that the colors are too good! The vibrant colors actually make an image look better than the same photo might look when printed through traditional means.

Other printers

The computer industry right now is putting a lot of effort into printers. High-end color laser printers offer excellent results and print out at much higher speeds than is possible with inkjet or dye-sub printers. Unfortunately, these printers are still very expensive and unlikely to be seen in small businesses or homes for a while. Like everything else related to computers, prices are falling and inexpensive, fast, color photo printing will probably be available in a few years.

Service bureaus

Sometimes, you need a particularly good print, a very large print or a slide made from your digital file. A digital lab or service bureau can be the answer. Like any service business, however, there are good digital labs and not-so-good labs. A lot of it depends on how well your particular way of working and your files work with the staff and equipment at the service bureau. You may need to do some testing to find the best one for you.

When you want really high-quality prints or larger prints, the service bureau is a great place to go. The Fujix Pictrographic printer, for example, offers very high-quality photographic prints up to 11x14 from digital files and is available at many digital labs. Labs offer other printing services such as Iris prints (very large images that can be printed on a variety of media), other large prints (3-4 feet and more wide and as long as needed), high-end dye-sub prints, text-and-photo posters and more. Most of these prints come from picture files saved as CMYK color. Check with your digital lab to see what files they need.

Service bureaus are also the place to get slides, transparencies and negatives from your image files. There are several reasons why you would want a final image put back into a traditional photographic form like these:

An Encad Croma 24 large format printer.

> **REASONS TO CREATE TRADITIONAL PHOTOGRAPHIC MEDIA FROM DIGITAL FILES:**
>
> 1. Film lasts longer.
>
> 2. Easy to make a quantity of prints quickly.
>
> 3. Color brilliance and immediate impressions.
>
> 4. Color matching.
>
> 5. Multiple image formats.

1. *Longer lasting.* Slides and negatives will last longer than most digital files, offering longer-term storage possibilities.

2. *Quantity prints.* Photos made for weddings or portraits can be made more quickly and cheaply from a digitally generated negative and traditional chemical means than by using direct digital printing.

3. *Sales and marketing.* Most art directors and editors are still impressed by the brilliance and color of a slide or transparency, and they don't have to wait for the computer to load an image. A big advantage of the computer is that you can consistently make identical slide duplicates from your original (after getting a good scan). You then never have to risk a valuable original leaving your possession once you have the digital file.

4. *Publications.* Your slide or transparency now gives the printer and art director or graphic designer an image to match.

5. *Multiple formats.* With the proper scan, you can get any size negative or transparency made from your original image, no matter what its size was.

Check with your service bureau to see what the file requirements are in terms of size and type. Since any of this work is a highly practiced craft, you will get the best results if you pay close attention to the requirements of the lab you are working with.

"No longer are your images confined to a print or a slide."

12 IDEAS, EASY TO ADVANCED

The computer can change the ways you look at a photo. No longer are your images confined to a print or a slide. Now the possibilities are endless. In this chapter, you will get some ideas to show what you can do with digital photography.

The easy ideas were selected because they are useful to many photographers, yet can be done quickly. Of course, "quickly and easily" is relative — don't be discouraged if a so-called easy project takes longer than you expected. Hang with it. All of these ideas will work.

1. Pictures in a letter (easy)

When writing to relatives, how about including a photo? Maybe of the kids, the new bicycle or even the trip to Florida. Here's one area where digital cameras really shine. You can take a photo, then nearly instantly insert it into a message.

Most word processors and desktop publishing programs allow you to work with text and photos in a letter. Here is a step-by-step method for including an image in your next letter.

1. Select photo and get it into your computer.

2. Save the photo at size appropriate to sending in a letter. You don't need a big image. Big photos require big files which will slow everything down.

3. Open your word processor and type the letter.

4. Open picture frame or box for a photo.

5. Insert the photo.

6. Decide if the photo should have text wrap around it (so it looks like the photo is surrounded by the words) or if there should be no wrap. Most pages look good with a text wrap, but the no wrap can give an open look that is very easy to read and understand.

7. Adjust the size and position of the photo on the page.

2. Letterhead (easy)

This is very similar to adding a photo to your letter, except that now you are putting in a photo in a specific position along with your name and address. Once you have the format done, you can save it as your letterhead and reuse it again and again. You can use the same photo, or change it regularly.

The steps are similar to adding a photo to a letter, above. What is different is that now you need to add interesting lettering. Type your name and address in any font to start. Size it and the photo so they look right together, remembering to leave enough space for a normal letter. Now, pick a typeface that seems to fit your personality.

Adding photos to a letter, either in the letterhead or in the letter itself, is an easy and fun way to share your photos with friends, relatives and even business associates.

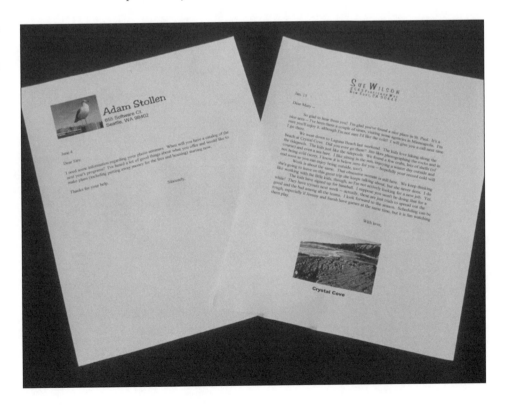

Keep the photo small. It shouldn't overpower everything else. Plus, a smaller image doesn't use as much memory. Don't use an image you have filed as a large image in the small space of your letterhead photo. Resize the photo in an image processing program so it is the size needed.

Another way of using the photo with a letterhead is to put the image on the background. You make a much lightened version of a low-resolution image (you don't need a lot of detail), then add it to your letter so it covers the whole page (or as much of the page as your software or printer will allow). Put your name and address over it. You'll also type each letter over it, too. To do this, you simply need to be sure the frame where you place your photo allows you to put text over the image.

3. Photo flyer and posters (easy)

Making a flyer or a poster with a photo is very simple. Such a page combines simple text with pictures to create a very effective way of communicating many things, such as a birth announcement, or a church group's play performance. It can also be a way for the pro photographer to show off photos for potential buyers.

When you start combining your photos with text as in this flyer, you'll find the possibilities fun and exciting.

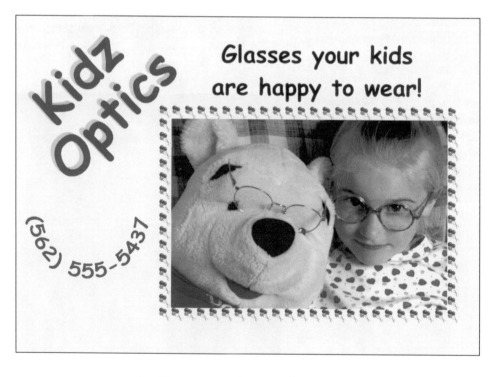

1. Choose your photo or photos

2. Write your text and think of titles before you start working. You need to have an idea of how the photo(s) and text go together, both visually and in content, and what needs to be on the page.

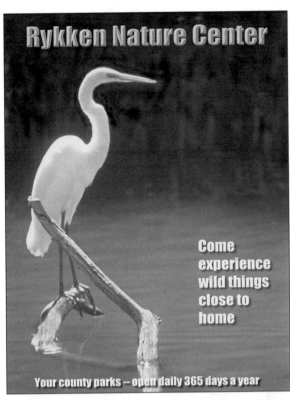

A poster is a relatively easy way of using and displaying your images.

3. Keep the words to a minimum. A flyer should be inviting. Lots of words often aren't.

4. Start with the photo. Put it on the page first to see how big it needs to be and where it should be on the page.

5. Add text and titles, balancing them against the photo.

6. Put a border or drop shadow behind the photo. This helps it stand out on the page.

7. Move and resize photo and text until they have the right balance of space and impact.

8. Add photos cautiously. Each photo will eat up memory, so keep them small.

9. Vary the sizes of the images so they can contrast and complement each other, rather than looking like an old photo album.

4. T-shirts (easy to intermediate)

Making a T-shirt with a your photo on it is mostly a matter of having the right printer and T-shirt transfer printing paper. You select your photo, add some text, print it out on the transfer paper, then iron it on. The slight hitch is that the image and words need to be printed backwards on the transfer paper for it to come

A photo T-shirt can be a perfect gift. Keep the image simple and dramatic for best effect and add text as needed.

out with the correct orientation left to right. There is some software available that automatically does this, but you can probably stick with your favorite image processing or word processing software. Here are some tips:

1. Choose a photo with bold, solid colors and a simple composition that clearly shows off the main elements of the picture. Fine details in photos will be lost in the transfer to the shirt.

2. Add simple text that can be read quickly. A few words are all that are needed.

3. Put the text and the photo together in the software.

4. Print it out.

5. Greeting cards (intermediate)

Greeting cards made in the computer are an excellent way to use your photographs. Send birthday cards, get well wishes, holiday greetings and more with your own special images.

A unique, personalized greeting card with your photo on it will get a great response from the recipient.

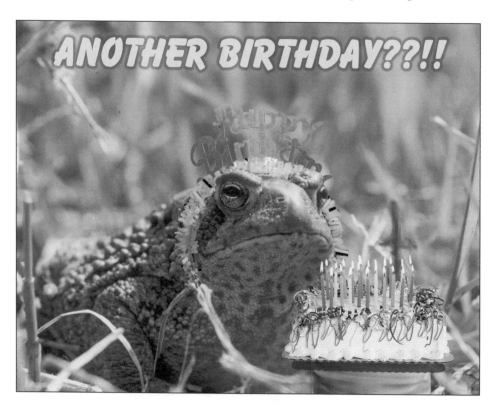

Here are three ways of doing greeting cards:

1. Print a photo on the highest quality photo print paper. Make a one or two-fold piece card on separate paper-with just text, then paste the photo on the front of the

card. The advantage to this is you can use the highest quality paper for the photo and use a different paper for the rest of the card.

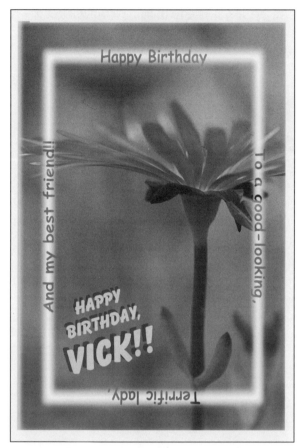

Many programs offer templates and borders to help with your card design. Even low-priced software usually includes some great text tools.

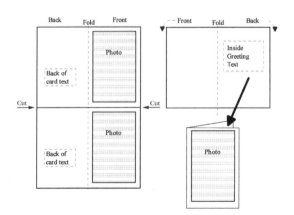

One-fold card

2. *One-fold printed photo card.* Set up to print two cards on a page. Print the photos on the right half of the page, one on the top half, the other on the bottom (as shown in the illustration at left), then print the page. Next, set up your text greeting on the right side of the page, for the top and bottom halves. Print this on the backside of the photo page already printed. It is a good idea to do some tests with cheap paper to check positioning of the photo and text before doing the final print on good paper. You can add text to your photo area, including a little "made by" on the left side. Keep photo pages without text to use for special occasions so you can personalize the text as you use the cards.

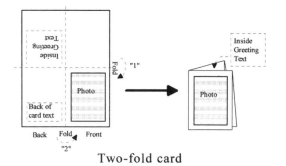

Two-fold card

3. Two-fold printed photo cards. This is a little trickier than the one-fold since you will have to put some text in a position that appears to be upside-down. After it is printed, you fold the page in half once, then in half the other way, just like a two-fold card you might get at the store. The photo starts in the lower right-hand quarter, right side up, but the inside text goes upside down in the upper left and right quarters. This may take a couple of tests to get everything printing in the right places.

6. Party fun (easy to advanced)

When many photographers think of making pictures, they think of the process as a very serious one. Yet, the new technologies offer some possibilities for light-hearted fun with friends and family, at a party or other gathering, especially with a digital camera. Here are some ideas:

1. Use a digital camera to photograph faces at the party. Put the photos into the computer, enlarge them to real-life size. Print out masks that people can use of each other's faces.

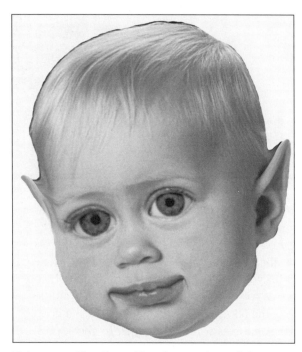

Take some liberties with a face and turn it into a fun mask for kids and adults.

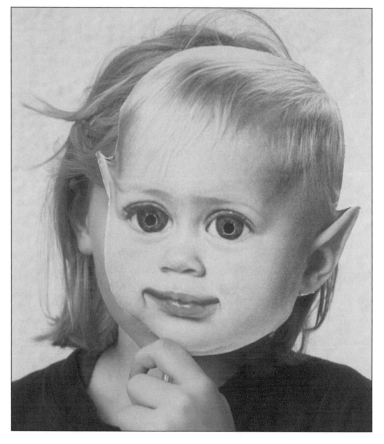

2. Take the faces and put them into a morphing or distortion program (or filter) in the image processing software. Make caricatures or funky masks. This is great fun with children.

3. Photograph all of the presents for a record and to include in the thank-you notes.

4. For a costume party, photograph the guests in front of a solid-colored background (this makes it easier to find edges), then composite them into stock backgrounds.

5. Have children draw an imaginary location they would like to visit. Photograph the kids against a solid background and composite them into their location.

7. Photos for display (easy to advanced)

Of course, just making a very nice print with a photo-realistic printer or having a dye-sub print made from a local lab might be enough for your print needs. With the computer, however, you can go farther.

Anyone can make printed materials, from cards to flyers, using computer photography.

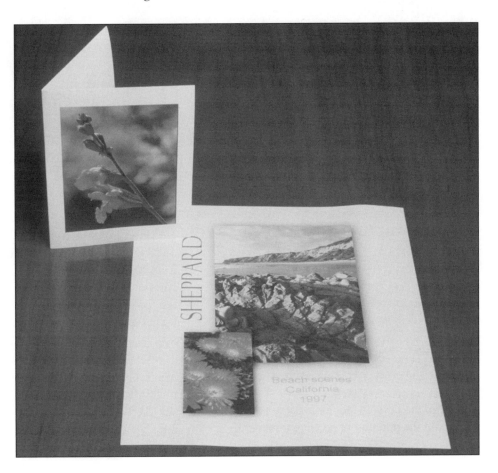

Edge treatments can be an effective way of presenting a photo. The simplest is a straightforward border. Some inexpensive programs produce great borders automatically. You can also make borders by increasing the canvas size without changing the size of the image. Select the border, then fill with whatever color you like that sets the photo off. Black is always effective, but can be a little stark. Colors work if you pick colors that complement either the mood of a photo (e.g., a red border for a playful child) or its colors (e.g., a gentle purple in a flower). The nice thing about doing this on a computer is that you can experiment and try all sorts of colors until you find the one you like best.

The addition of an edge provides the finishing touches for an old-fashioned, black-and-white portrait.

A print of the Lincoln Memorial gains added richness with the addition of an edge treatment.

An interesting color border can be made from a color gradation. Pick two colors that work with the photo, then set up a gradation from the top of the selected frame area to the bottom.

Other edge treatments actually change the edge of the photo from straight to some interesting pattern such as torn paper or a hand-drawn design. Some software offers edge treatments within the program. Any program that allows Photoshop plug-ins (including Adobe's image processing programs) can use add-in software that includes a whole range of edges.

You can create your own edge treatments. This is done by again adding the white border then using the cloning tool, the paintbrush or the airbrush tools to move white along the edge of the photo in whatever looks interesting to you. If you really like a pattern you create, save it.

8. Newsletters (easy to advanced)

Newsletters are a lot of fun and a great way to integrate your photos with a message. They can be a simple letter of news to relatives with an added photo or two, or they can be as complex as a group's newsletter with multiple columns, headlines, captions and everything you'd expect from a newspaper. They can be a way to update family members who are spread across the country or a way of communicating about your organization or business.

Simple newsletters are easily done in a word-processing program. Type your headline and text in very simply, then add the photos. Now that you have an idea of what the page will look like, go back and center the headline and choose an attractive typeface and size. It helps to do the headline when you can see the text and photos. Decide if the text should wrap around the photos (which uses space on the page better).

As you decide to add columns, more headlines and photos, you will be better off going to a publishing program. There are some inexpensive ones that will do the job for most non-artists. These programs are fairly easy to use and they often have newsletter templates into which you can insert your own headlines, text and photos and end up with a good design. As you make up your own design, using more columns, different photo treatments, and so forth, the choices become more challenging.

Be conservative in the use of color and varied typefaces. You are trying to draw attention to your photos, not design. Plus, too many typefaces on a page can make it hard to read.

Newsletters get a message across with the added color and impact of your photographs.

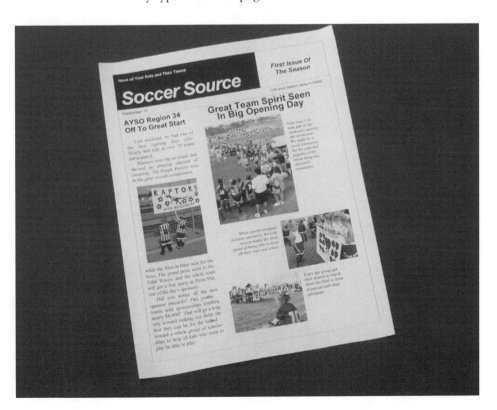

9. Calendars (easy to advanced)

The easiest way to do a calendar is to buy an imaging program that offers calendars. These offer all of the months, with the correct format as to days and weeks, with a simple way of adding your photo.

If you don't like the designs available, and you like the challenge of doing it yourself, you can make a calendar from scratch through a publishing program. Use the calendar template they have (the month with days and dates) or make up your own with the Tables tool. This can get quite advanced as you add more

You can't go wrong with a calendar as a way of displaying your photos. They make great gifts for the family and excellent promotions for a small business.

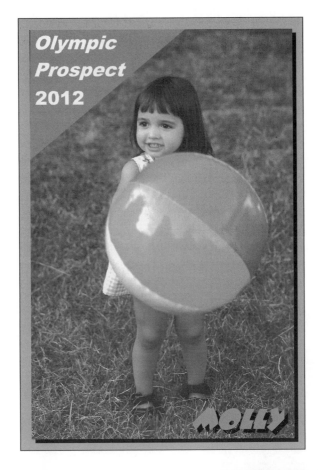

than one photo to the calendar (such as one big one and then a small one down in the corner) and change typefaces. Keep the typefaces simple and direct, with short text, to make a calendar readable from a distance.

10. Sports cards (intermediate to advanced)

Now you can make your own sports cards and pages, featuring your own personal favorite players, whether they include a son or daughter, nephew or niece, grandson or granddaughter. Some image processing programs offer pre-set card "frames" into which you just insert a photo, or you can design your own.

Basically, the cards include a photo of the star, plus some type with name, team and so on. Use whatever you like for wording and don't feel you have to match real cards. Use a simple, sans-serif typeface (such as Arial, Helvetica or Impact), because they have a bold readability when used with a limited number of words. That's also what the pro sports cards mostly use, so your cards will look more like the real thing. If your program allows you to rotate the type, try putting some words at an angle in the corners.

The cards also include color bands, borders and decorative elements. Here you are constrained only by your imagination and the limitations of your program. Put color blocks with type in areas of the photo that can be covered without bothering the subject. Try to balance their position with other blocks or the subject.

Sports cards let you feature your favorite players in a very fun format that is great to share with others.

As to colors, pick ones that you like. One approach is to select colors that match the uniform of the subject. Or you can select colors that reinforce some colors in the photograph (a classic way of using framing mats with pictures). You can also pick colors that you feel just better reflect the subject — bright colors will usually fit a young child, for example, better than more subdued colors, which would probably look better with an older player.

11. Labels (intermediate)

Photo labels are impressive. They are still new enough and not seen by everyone so they make an immediate impression on people who receive your letters. Labels on sheets for the printer (such as Avery's) come in all sorts of shapes and sizes.

They can be a little tricky in that you are basically making multiple copies of a small photo and text for a page, and they have to line-up with the pre-cut form. Do a bit of test printing with cheap paper, then hold the printed page up against the label

Photo labels are a very distinctive way of making an impression on others. Use photos with strong, simple compositions and bold color.

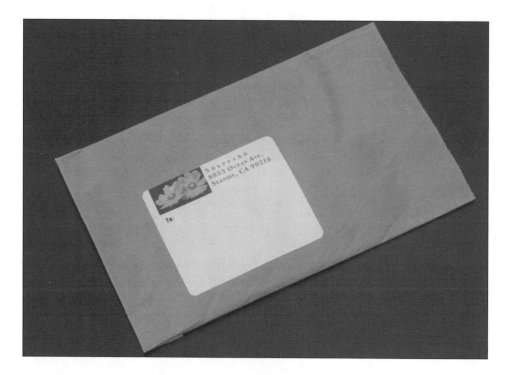

sheet to see if they line up (hold it up against a window, light or light table).

Make your first label singly, looking to see how text and photo go together, then print it out to see how it looks. If it works, then you can copy it into the spaces for the others on the page. Be sure your photo is only as big as needed (in other words, if your image is one-inch square, don't use a photo that is filed as a five-inch square). If you start running out of memory as you add in the

photos in all of the label spaces, go back and further reduce the resolution of the photo.

Label page manufacturers now usually offer instructions on setting up a page in most word-processing programs. You can usually use publishing programs, too. It's easiest if you set up a grid (a table is perfect) that matches the labels as die-cut on your label page. Photo labels work great for address labels, shipping labels, bottle labels, photo stickers, and more. Use your imagination. Anything you would use a sticker for, you can now use one of your photos.

12. Brochures (intermediate to advanced)

Brochures are really a sophisticated variant of putting photos on a flyer. The tricky part is dealing with the folds. The easiest way to make brochures, and keep the folds straight, is to use a desktop publishing program. Here are some tips for using your photos effectively:

1. Use your boldest, simplest photo on the cover and use just one! Too often people clutter up covers with a lot of type and photos that are hard to read. Grab your

Modern desktop publishing programs let you make your own brochures. Their message is strengthened, of course, by your photos.

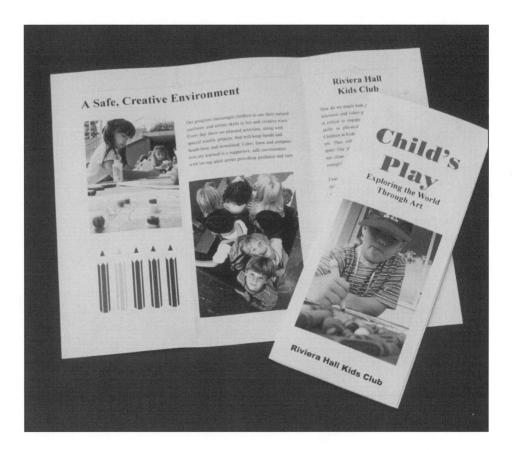

reader's attention, and pull him or her into the brochure. Make them interested in the photos by proudly displaying a good one on the cover.

2. Use a few large photos rather than a lot of small photos. Large photos always make a good impression. With photos in a brochure, you want to communicate something to the reader about your work, not just tell them you have lots of pictures that are hard to see and understand.

3. Use a very few small photos to counterpoint the large ones. This actually makes the larger photos look bigger.

4. Keep text simple and short. Don't overburden a photographic brochure with words. Keep to the important points, highlighting them as needed, and let your photos tell a story.

5. Use big and bold headlines. Keep them short and quick to read.

6. Add borders or drop shadows to your photos. This makes even an inexpensive brochure look better.

CHAPTER 1 1

STORAGE

One thing becomes immediately clear as you work on photos in the computer — they take up storage space on your hard drive like a hippopotamus in a bathtub. And when you want to take your digitally filed image somewhere, such as a service bureau or to bring it to or from work, you need a way of storing and transporting that image. The traditional 3.5-inch floppy often won't do the job.

Floppies

The 3.5-inch floppy disk has been and continues to be the way most information is physically transported from computer to computer. Unfortunately, most photo files are too big to fit on the standard 1.4 MB disk, so their use is limited with photographs. A new 200 MB floppy drive was recently introduced and promises to be a very versatile storage device.

That doesn't mean you can't use standard floppies. You will, however, usually have to use JPEG or other compression to fit your photo files to them. Compression means loss of image quality, but if you keep the compression to a minimum, using the highest quality settings, you can put good-sized, high-quality images on a floppy disk.

You can also use more compression along with smaller files to fit a whole group of photos onto a floppy for portfolio purposes. There are a few programs available that do just this, some add music and image transitions. The image quality won't be good

Removable storage disks are important accessories. The Zip disk on the left holds over 60 times the storage of a standard 3.5-inch floppy on the right.

enough for printouts, but will be fine for displaying on a computer screen. Nearly everybody has a floppy drive, so you can expect almost anyone with a computer to be able to view these images.

Hard drives

Unless you bought a mega-gigabyte hard drive with your computer, the hard drive that came with your computer may seem to be shrinking. Photos need SPACE for storage on your hard drive. Also, a portion of the hard drive always needs to be free for your imaging programs to use as virtual memory or a scratch disk. Because photo files can be large, keep at least three times your common photo file size free on your hard drive (e.g., 30MB for 10MB files). Some programs require more or less free hard drive space. Generally, the more available space, the better.

As your hard drive fills up, you have two choices: add removable drive storage (Zip, Syquest, Jazz, etc.) or add another hard drive. Adding a hard drive is relatively easy to do (most hard drive suppliers offer good instructions), or you can have it done at a local computer store. The new drive can either replacing the existing one or be added as a second drive.

Large-capacity disk drives

An alternative to adding a hard drive is to add a drive that has removable storage media. This works well as a place to keep your photos as you can "file" pictures on different disks. The disadvantage is that some of these drives are slower than a hard drive and are more expensive in terms of cost per MB. However, they are usually easier to install and offer more flexible options.

The Zip drive has become a de facto standard for transporting larger files, such as photos, from computer to computer.

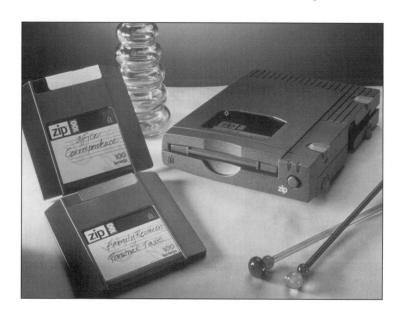

The Zip drive has become a *de facto* standard in larger capacity disk drives. It works well for photos. The drive is easily added to your computer, each disk holds 100 MB, the price is reasonable and disks are relatively "portable" in that most service bureaus and businesses can read them. Many professionals shooting for magazines now use them to send work to publications. A Zip drive installed using your printer (parallel) port will be quite a bit slower than one that connects directly through a SCSI or USB connection. Syquest also has a well-earned reputation for drives that are standard in the graphic design industry. Their line of drive types and capacities has expanded.

Both Zips and Syquests are magnetic media, and as such, have a limited life before the magnetic signal, the stored information, deteriorates. Don't expect them to have good storage beyond ten years, although under ideal conditions, they may last longer than expectations. Magneto-optical drives are less common, but feature more permanence (over 30 years) and lower per megabyte costs for the storage media. They are, however, less portable as there is less general acceptance and support of the media.

In larger storage media, Iomega and Syquest offer drives with gigabytes of removable storage. You can get a lot of photos onto a gigabyte or two, plus by being able to remove the media, you can actually organize your files by disk. These drives are fast enough that you can actually use them as substitute hard drives (for virtual memory, programs and more).

You can get gigabytes of storage for your photos with drives like the 1.5 GB Syquest SyJet drive.

New drives with giga-storage come on the market constantly, offering photographers more choices on how to store their images. This is Castlewood's Orb drive.

CD-ROM discs have become a popular way for professional photographers to store and share images electronically, and they are not as effected by time as magnetic devices. The writable CD-ROM used to be a challenge to use, and the drive to write to it was very expensive. New writable CD-ROM drives and software have made this a very easy-to-use and quite cost-effective medium, allowing you to store over 600 MB on a single inexpensive disk. One great thing about CD-ROM disks is that nearly everyone with a computer can read them since most computers have CD-ROM drives. That makes the photos on them highly portable.

CD's are still one of the best ways of storing and transporting photo files, with some of the best archival qualities of any digital storage device.

The standard writable CD-ROM can have data saved to available space one time (either all at once or in multiple sessions), then the disk cannot be erased and reused. Re-writable CD-ROM drives allow you to erase and re-use a disk. Re-writables are still expensive, both drives and media, but will potentially be cheaper in the future. Writable DVD drives are coming down in price and may be a more viable alternative in the future.

Writing CD's used to be a pain to do and the drives were very expensive. That has changed dramatically, making CD-R's an excellent choice for photographers.

Organizing and retrieval

Once you have all of your images filed, how do you find them? Quite a few programs are now available to help you organize and retrieve your photos. Many new image processing software programs are even coming out with filing capabilities. Most of them are not very powerful, so you may want to look into separate storage/album programs.

Look for a program that will organize all files across multiple storage media. Look for software that includes thumbnails of some sort. It is very helpful to see a small picture of your image besides file info. This software does not copy the whole image into the program, instead, it records information about the photo and where it is stored. Using this info, the software can prompt you when you try to get a particular image.

A database can help, although this is highly dependent on how much time you want to take organizing it. Look for a database search option and a database that allows you to put in more than a few words. Some organization software lets you keep photos in "virtual" photo albums. This can be a nice feature especially if you want to share your images with people by passing around a CD-ROM or sending them over the internet.

CHAPTER 12
THE INTERNET AND WORLDWIDE WEB

The internet was an interesting phenomenon from the start. Used mainly by scientists, engineers and academics, it was, at first, very much a text-based technology.

Technology changed, allowing the use of photos on the internet, and the worldwide web was born. People could now have interesting home pages with photos and other graphics. E-mail could be sent with photos attached. You could actually see a company's products displayed on-line.

Unfortunately, all of the hype during the early stages of the web caused a lot of people to believe it could do more than it really could. Photos? Great! Lets put lots of them on our home page — big, beautiful images, too. Let everyone see what we do. Let's get great graphics.

That didn't work. Download times became extremely long. Computers crashed. So now the web sports sites with smaller, less detailed photos that can download quickly. Eventually, connections with the web will increase in speed and volume capacities, so photos can be downloaded faster. That will mean higher resolution photos, as well. And you'll be able to e-mail larger files without making your system crash. We are likely to see some new ways of handling photos over the web so they can move more quickly and easily.

"We are likely to see some new ways of handling photos over the web..."

Moose Peterson has found using a web site on the internet to be a great way of getting his images seen by people from around the world.

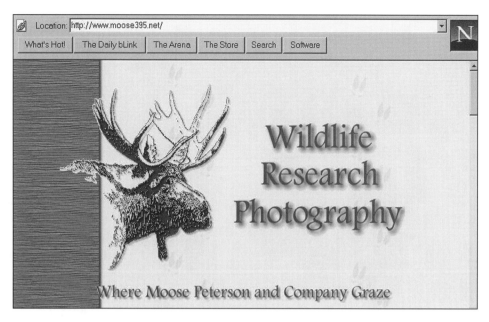

E-mail

Sending photos around the world within moments is a very exciting possibility. You simply attach a photo to your e-mail and push the send button. It sounds good, but there are some complications. It is not so push-button easy as some people would make it sound.

With e-mail, you can send fun photos quickly to family and friends nearly anywhere.

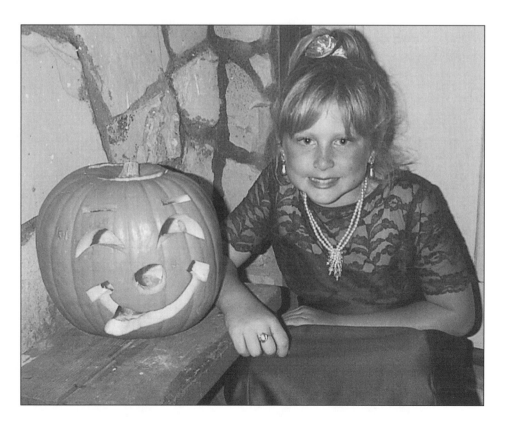

If you are using the phone lines for your internet connection, like most people using the internet, photos take a long time to transfer. The bigger the file, the longer it takes, even if you have the most up-to-date, super-fast modem. Someday, this will change, but for most people, it will be a while. Additional problems arise with "noisy" phone lines and static that can corrupt files so they don't work. If your screensaver comes on while you are downloading, your whole system might crash.

What can you do? Use the smallest file size you can. A 100 kilobyte file will upload in minutes, a 1 MB file will tie up your machine for many minutes and a 10 MB file ... well, you might as well go out for lunch during that transfer and hope the computer doesn't crash.

Your best bet is to send compressed files. There are a number of compression utilities available that are designed to compress files on the web, however, not all of them do a good job on photos. Plus, some e-mail "gates" (the systems used to process e-mail at servers) won't always treat compressed photos well and your recipient may find that they are unable to open them.

Most people send photographic images compressed as JPEG files (a file format named after the Joint Photographic Experts Group — actually computer engineers). Almost all image processing programs can save photos as JPEG files. These files are compressed by taking out what the software thinks is redundant data, therefore JPEG compression does cause information loss and quality degradation.

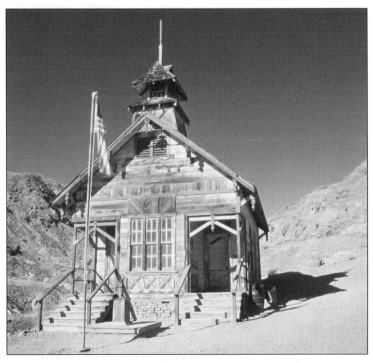

An uncompressed file shown at 500% above and 100% at right. Original file size 1.3 MB.

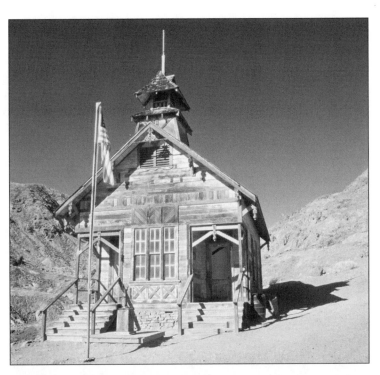

A JPEG file with moderate compression shown at 500% above and 100% at right. File size 260k.

A JPEG file with high compression shown at 500% above and 100% at right. Files size 163k.

You do have a choice as to how much compression is used. The more compression you use, the smaller the file, the faster it goes through your phone lines, but the poorer it looks. Some programs, such as Ulead's PhotoImpact, actually have a JPEG viewer to see the effects of the compression as you go. Without a pre-

view, you have to save the file, then reopen it to see how compression has affected the file.

There is one little quirk about e-mail and JPEG photos. If you send a JPEG image from a Mac to a Windows machine, the Windows machine will not recognize it unless the file name ends in .jpg. You can label it so, or you can tell the recipient to re-label the file before trying to open it.

GIF is another compression format common to the web. A GIF will transfer quite quickly because of a reduced file size. GIF translation also removes some important color information. If you care about the color of your image, use JPEG compression.

ORIGINAL

Compuserve GIF

Above, the top image is the original; just below is the same file as a GIF. At right is a side-by-side comparison.

Many of the newest image processing programs offer direct internet capabilities. You simply call up a photo, then tell the program to send it to an address on the web. Assuming you are connected, the software then allows you to add a brief message before compressing the file and sending it on its way. If you are interested in frequently sending e-mail postcards to friends and

relatives, this might be a good reason to expand your image processing programs on your computer.

There are several, inexpensive, dedicated e-mail "postcard" programs that also do the job. They don't allow you to do much adjusting to the photo, but they do provide a quick and easy way of putting text together with a photo to send across the net. Several even allow music and short narration.

Web sites

It wasn't that long ago that making a website was a major undertaking attempted only the by computer wizards who understood HTML programming. Consequently, websites were expensive, and they were mostly constructed by businesses.

That's no longer true. Today, anybody can make a web page. New and easy web site software seems to come on the market every day. You don't need to know anything about HTML or any other programming to create a basic website. All you need to know now is how to use a word processor.

Professional photographers are producing websites to show off their photos. Young parents make special sites for friends and families to see what the new baby looks like. Travelers use them to share images from their journeys. Small businesses have found web sites work great to sell their products.

Making a web site today is fairly easy. Just keep it simple, like this one from Paul's Photo. Too many photos or photos that are too large may create problems for the people visiting your site.

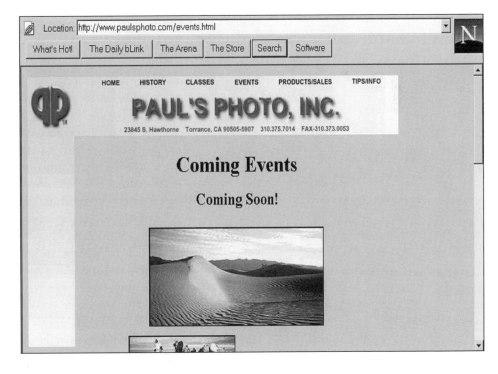

To make a web page work, you have to be conscious of the viewer. Too often people start putting cool photos and backgrounds on a page because they can do it, rather than to help the

viewer. It is important to understand that other web sites are a click away, and if a viewer gets impatient or annoyed because of the site loads too slowly, they move on.

Bill Neill's web site is a perfect example of displaying fine photography well. The site downloads quickly because of the simplicity of its design, yet the photos look very handsome.

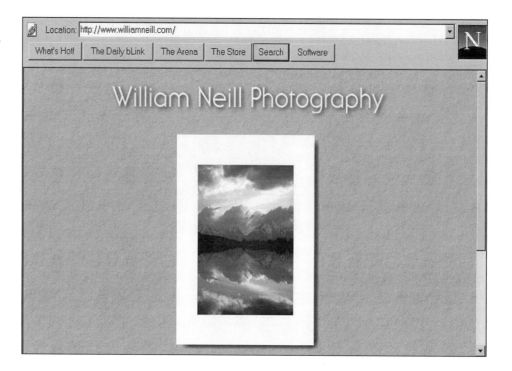

Programs that allow you to put your photos on a web site come in three types: simple templates, dedicated server programs and word-processor-type fully adjustable. For any web site, you need a place for the site. Your provider or internet service may offer space on their servers for websites. You pay a monthly fee to "rent" that space. Check with your provider for details.

The simple template programs are usually quite inexpensive and very easy to use. Backgrounds and graphic treatments (such as headlines) are already done, so you don't have to worry about them. You just fit your photos into the right places, type in your words and download the whole thing to your internet provider. Although you can't do much adjusting to the template, you get a professional-looking site for less work.

Dedicated servers will keep your photos available for view on the web for a monthly fee. You usually have few options about customizing the site, but you often don't have to do much to it. If you want, you can usually keep your photos secure from unknown viewers by requiring a password. Some of the providers of these services actually require a password (which you can share with friends and family). Many photofinishers also offer such a service — you have your photos processed by them and they post your pictures to the internet for a certain time period.

A fully-designed, totally custom site can be quite dramatic and fun. New programs have come out that allow you to create your

web site and do it as easily as you would handle a document in a word-processing program. You can use big photos or small photos, but remember accessing your site will become more difficult if files get too big.

Tips for making web pages:

1. Keep photos small. If your original photos are big files, make them smaller. Visitors will never stay with your site long enough to look at the photos if the site is too unwieldy to download. GIF files are common to web pages because they download fast.

2. Keep photos to a minimum per page. It's a mistake to cram everything onto one page. Use some space around your images so they don't look crammed.

3. Use thumbnails for photos to link to larger images. You don't have to go for the "big" photo on every page.

4. Keep the background simple. Because you can do some fun colors and patterns, doesn't mean you always should.

5. Avoid black as a background color. It is dramatic. For a while, it was very common and very popular. But type can be hard to read against the black and it makes the pages look tired and heavy.

TIPS FOR MAKING WEB PAGES:

1. Keep photos small.

2. Keep photos to a minimum.

3. Use thumbnails as links to larger photos.

4. Keep the background simple.

5. Avoid black as a background color.

CHAPTER 13
CONCLUSION

Times really are changing for photographers. You can take pictures, process them, use them and share them in totally new ways. That adds up to new possibilities for your images and new ways of having fun with photography. Some proponents and critics, have gotten caught up in the digital of digital imaging and forgotten the importance of the image. The computer is a tool, and while it can be fun, it is the image that is important, not the gigabytes, software programs, printers or technology.

The possibilities for making tremendous photographic images with the help of a computer are endless, addicting and a lot of fun. The more practice you have, the better you will get, and the more powerful the program will seem. Inexpensive PictureIt! can do more for an image in the hands of someone who's really worked the program, than the high-end Photoshop with someone who hasn't put the time in.

Spend some time playing, experimenting, making mistakes and learning with your images and your equipment. There is a learning curve, and the first few hours tend to be the hardest. After that, image processing starts to be more fun as you see things change before your eyes.

The computer has become the darkroom of the future, for color and black-and-white. It doesn't require a special room, noxious chemicals, dark surroundings and it has no toxic chemicals that must be flushed into the environment.

Have fun as you explore this wonderful new age of imaging. You'll be taking more photos and enjoying them more, tool!

APPENDIX 1:
PHOTO FILE FORMATS

All of the different formats available to handle and store images in the computer can be confusing. For photographers, TIFF and BMP are very important because they file photos in the original, uncompressed state (although you can compress TIFF files). JPEG is also very important because of its ability to compress files to send them off to others. FlashPix is becoming more common with some editing programs and could become very important on the internet. Other formats are mainly for specific programs or purposes, and if you run across one, you don't need to know much about them except that they work with one of your programs. You can usually convert them to the more standard file formats when needed.

TIFF and JPEG files are about the most universal formats read by nearly every software program that can use photos and among the few that are directly compatible cross-platform (Windows and Mac). Mac computers can read TIFF and JPEG files from both Windows and Mac formatted disks. Windows machines can only read these files from a Windows formatted disk. Consequently, when a disk must go cross-platform, there are no special needs for using the Mac. However, to go to Windows, the Mac file must be saved on a Windows-formatted disk and file extensions have to be added or the file type will not be recognized. That means TIFF files have to be named with .tif and JPEG files with .jpg at the end of the name (no spaces).

BMP — Windows Bitmap file. This was originally developed for the Windows environment in an 8-bit format (which

gave only 256 colors, not enough for imaging work). Now it is a fully 24-bit format (offering 16.8 million colors, plenty for photos).

GIF — Graphics Interchange Format. Really just an internet graphics file as it only handles 8-bit color (256 colors). The reduced colors do make files smaller.

JPEG — Joint Photographics Experts Group. This is a compression format: the program using it compresses the photo file (makes it much smaller) by tossing out what it thinks is redundant information. This is called "lossy" compression because data is lost. At low compression levels, the image still looks excellent (although it is not a good idea to compress and uncompress a file many times), but as compression ratios get higher, more and more data is thrown out, so the image will degrade in quality. This is a 24-bit format (16.8 million colors) very useful in sending images over the internet, in giving someone an image with a floppy disk or in any situation where storage is limited and you need to keep file sizes small.

TIFF — Tagged Image File Format. This has become a standard format for nearly everybody and every program. If you file an image as a TIFF file, you can count on someone else being able to open it at another computer (given the Mac/Windows limitations as mentioned above). This format has full 24-bit color (16.8 million colors) and includes a lossless compression option (compression that does not degrade the image).

PICT — not as common as it once was, this older Mac format does support 24-bit color.

APPENDIX 2:

PROCESSING POWER, RAM, HARDWARE AND SOFTWARE

When you buy a computer, by the time you get it in the car, the price has dropped, and the manufacturer has announced a new processor or a bigger hard drive.

Can we ever keep up?

No. But then we don't have to. You don't need to buy the latest offerings in hardware and software to work on your photos. The thing you need most is a basic understanding of how all of this works and how that relates to your situation. Slower computers, older software will do the job, although perhaps not as fast or with the latest interface.

There are some minimums for you to really get going and enjoy working on your images at the computer. If you have an old 486DX66 processor with Windows 3.1 or an old Mac Quadra or PowerMac 7100, you can get started, although this equipment is really a minimum, and you will probably be frustrated by its lack of speed. More powerful Pentium machines, PowerMac's with a G3 processor and other modern computers will rapidly handle the adjustments you make on an image without making you go out for coffee while they think about your commands (this really used to happen not all that long ago).

However, RAM is more important than speed. If you have to cut back somewhere because of cost, use a slower processor and more RAM. RAM is the internal active memory of the system.

Photographs rapidly use up RAM, and some programs hog it more than others (Adobe's Photoshop needs 2-3x more RAM than the actual size of the photo it is working on). You cannot have too much RAM! You will find it difficult to work on even small images with less than 16MB, and 32 MB is a better minimum.

As you work with larger and larger images files, that RAM requirement increases. Be sure your machine can handle large amounts of RAM so you can install more to upgrade. 32 MB will be okay with moderate-sized photos with files of 5-10 MB. With 64 MB of RAM, you can start working on a high-resolution 20-30 MB picture in many programs. Very high-resolution images, such as 35mm for big prints, or medium or large format images scanned onto Kodak's Pro Photo CD, can reach 40-60 MB in size and will require not only a lot of RAM (128 MB or more), but also a computer that can handle that much RAM.

APPENDIX 3:
10 TIPS FOR COPING WITH THE COMPUTER

1. Save often. Computers crash. It's a fact of life for all platforms. Save as you work on an image. If you're not sure you'll like everything you're doing, use the "Save As" command and rename your file. "Undo's" are fine and helpful, but they can take time to get to an earlier version. If you've already done a "Saved As", you can get to that version faster. Plus, "undo's" do no good if the computer crashes.

2. Restart and reboot. Sometimes computers act like humans and get confused. If your program starts doing weird things, all you might have to do is exit out of the program and restart it. If the problem persists, you may need to close all of your files and reboot (restart) your computer.

3. Read the manual. Hardware and software manuals aren't always the easiest to use, but they do have good information on troubleshooting problems. The "read me" files that come with software also often clarify system and software bugs or conflicts and may offer the solution you need.

4. Learn keyboard commands. The mouse is great, but it can be slow and limiting. You can often access image editing tools, for example, by using simple keyboard

commands. Those commands are usually listed on the pull-down menus and in the manual.

10 TIPS FOR COPING WITH THE COMPUTER:

1. Save often.
2. Restart and reboot.
3. Read the manual.
4. Learn keyboard commands.
5. Back up.
6. Get help.
7. Check internet for upgrades and fixes.
8. Use virus protection.
9. Use system monitoring software.
10. Accept incompatibilities.

5. Back up. This is important. Duplicate all of your critical files. There are programs available that make backing up of files a controlled process, but even if you just save important images to a floppy or a Zip, you'll thank yourself when you can't get at the image on the hard drive.

6. Get help. Call the hardware or software company's tech support line. The quality and friendliness varies here, but if you are assertive, you will get your problem taken care of. Also, try going on-line to access technical support and message boards that often have answers to problems that users have encountered and solved.

7. Check internet for upgrades and fixes. Often when problems are discovered with software or hardware, the manufacturer will make a change (or "patch") and usually offer it on their Website.

8. Use virus protection. If you transfer any files at all, either through the internet or on removable disks, and even if you just share a floppy with a friend, protect yourself from very serious problems by adding a virus detection program to your computer.

9. Use system monitoring software. There is software available that will detect and automatically fix hardware and software problems, interrupt a crash so you can save your work, provide a means for recovery from a crash, and even offer virus protection.

10. Accept some incompatibilities. Certain programs and hardware may never work well together (and this goes for both Windows and Mac environments). You may have to choose one program over another or accept these annoyances.

Appendix 4:

Software Image Processing Programs

This listing of some commonly available programs will give you an idea of what is available and what you can expect. Software comes and goes almost like the wind, so use this only as a rough guide as to what is available.

Adobe PhotoDeluxe — a low-priced program from Adobe that is based on the Photoshop "engine" as Adobe describes it. The interface is extremely easy to understand and use and offers totally icon-based choices for the beginner or a full menu for the advanced user. Many of the tools found in Photoshop are also here, although with less settings. The program also offers some unique step-by-step processing choices that make the work easy. The program comes with templates for frames, cards and calendars.

Adobe Photoshop — the standard in high-level image processing for years. Extremely powerful and flexible with many possibilities that no other program can match. Tools aren't just tools, but tools with settings — you can control most of them for everything from a subtle to extreme effect. Layers give the program a great deal of flexibility. However, this very power and flexibility make the program a bit intimidating and requires you spend a bit of time with it to really understand what to do. The interface is very straightforward but not particularly intuitive.

ArcSoft PhotoStudio — sometimes called the poor man's Photoshop because of its interface and tools, which even have some setting capabilities. A lot is built into the program, yet it has a small "footprint" (meaning it doesn't take up a lot of room in RAM) leaving more room for working on the images. The program also includes quite a few special effects to create some unusual looking shots. The interface is straightforward and menu-based. You do need to use it a bit to gain the most from the tools available.

ColorDesk Photo — a very simple program without a lot of tools to work with, also one of the quickest and easiest programs to use. You can't do extensive adjustments to an image, but it is perfect for a quick adjustment of a family snapshot before adding it to a letter or sending it attached to an e-mail. The program includes a nifty way of adjusting images by comparing your shot to other images the program "knows."

Kai's Photo Soap — this program is totally unlike any other and always will be. The interface is very graphic and intuitive once you get used to it, but it will drive a dedicated Photoshop user crazy. The program uses actual brush, eraser, paint can and other "art" icons for its tools and you usually brush the effect onto the image. You can also erase the effect if you make a mistake. It has one of the best dust and scratch removers in any program. You literally paint out the scratches and dust.

LivePix — a good little program known for its outstanding compositing capabilities. The program processes images differently than most other programs so that it needs less RAM to operate. You can actually bring several high-resolution images together on a page and move them around in real time without waiting for the program to "think." Its text capabilities are outstanding as are its abilities to do cutouts and drop shadow effects.

MGI PhotoSuite — a low-priced, under-appreciated program with a lot of extras such as picture frames, baseball card templates, calendars and more. The program is looks and acts like a web-site with lots of easy to use buttons for controlling the image. This program comes bundled with a lot of gear and offers a lot for the price. The company is constantly offering new templates for new ways to use your photos, from wedding photo frames to holiday cards.

Microsoft PictureIt! — another under-appreciated program. People seem to think that because it is inexpensive, it can't be that good. It offers some great, intuitive and very powerful image editing tools. All images are turned into

FlashPix images, which makes for good speed while processing, but slows the loading of the image. You may want to change the default settings for bringing photos in and out of the software — they may set resolution lower or higher than you might need. The program comes with templates for frames, cards and calendars, and even includes a sophisticated set of edges for a very trendy look to photos.

PictureWorks HotShots — this program offers comparison images to show what the tools do for almost every standard adjustment you want to make. You don't just see the image after its been changed in color or brightness/contrast, you actually get a choice of images that show you what happens if you use more or less of the tool. The tools don't offer a lot of flexibility, but then you can see exactly what you are getting, with choices, so you can more easily decide what works best for you.

Ulead PhotoImpact — a mid-priced and quite powerful program that offers some unique features not found on other programs. Most of the standard features, from selections to cloning, are here. A lot of image work is shown in small before and after previews that make it easy to see what your effect will be before you actually tell the computer to go to work. For Internet photo usage, there is a GIF and JPEG viewer to show you what your images will look like once compressed, but before the compression! You also get a nifty album feature to catalogue your pictures.

Wright Image — a very interesting program relatively new to the U. S. Originally developed in Australia, this very powerful program takes some use to really learn its capabilities, like Photoshop, but unlike Photoshop, uses the computer's memory very efficiently, allowing you to work with large images (or multiple images at once) with less RAM.

Xaos Flashbox — a wild program that encourages you to do really play with your image in fun and creative ways. Not for the traditional photographer, and it won't work with big images, but you can change a photo from top to bottom to make fantastic creations.

APPENDIX 5:
WEB SITES & DEMOS

One good way to learn about a piece of software is to try it out. That's difficult if you have to buy it at the store. Many companies do offer downloadable demos at their web sites. In addition, the sites will often offer tips, tutorials, software updates and patches, and technical support to help users make the most from the companies' products.

All sites here begin with the standard http://. They are in alphabetical order by company name. The company's image processing software is noted in parenthesis. All of these were correct at the time of the book's publication, but web sites are dyna mic and can change. Downloads vary in size and the time needed to actually bring them into your computer. Downloading in off-peak times, such as late at night, can make it go faster.

Adobe (Photoshop, PhotoDeluxe) - www.adobe.com - a very full web site with lots of tips, techniques and downloadable demos and plug-ins.

ArcSoft (PhotoStudio) - www.arcsoft.com - trial version available, plus information on some unique imaging software.

ColorDesk (ColorDesk Photo) - www.ColorDesk.com - demo available plus an "internet shopping mall for photo related products.

G & A Imaging (PhotoRecall) - www.ga-imaging.com - demo of album software.

ixla (Digital Camera Suite, Web Pages) - www.isr-group.com - demos of strong digital camera tools and easy web page software.

LivePix (LivePix) - www.livepix.com - trial version plus tips and ideas.

Metacreations (Kai's Photo Soap, Photoshop plug-ins, Painter) - www.metacreations.com - products with distinct character. Demos available, plus tips and special downloads.

MGI (PhotoSuite) - www.mgisoft.com - trial version plus ideas and tips.

Micrografx (PicturePublisher) - www.micrografx.com - web oriented tips and product demos.

Microsoft (PictureIt!) - www.microsoft.com - trial version plus tips and ideas.

New Soft (PhotoAlbum) - www.tophat.com - some demos; album software.

PictureWorks (Hot Shots, Spin Panorama) - www.PictureWorks.com - lots of info about a diverse range of products and demos available through sales department.

Ulead (PhotoImpact) - www.ulead.com - some free downloads of web related products, plus demos.

Videobrush (Videobrush Panoramic, Photographer) - www.videobrush.com - evaluation download.

VividDetails (Test Strip) - www.vividdetails.com - demo of Photoshop plug-in.

Xaos Tools (Xaos Tools, FlashBox) - www.xaostools.com - lots of special effects and Photoshop plug-ins, demos.

Wright Technologies (Wright Design, Wright Image) - www.wrightna.com - very helpful tutorials available (don't try the programs without them), plus demo downloads.

APPENDIX 6:
GLOSSARY

bit — the basic piece of information used by the computer (a binary device). Often used with color as in 24-bit color, meaning that there are 8-bits (basic units) of color information available for each of the RGB colors used by the computer.

BMP (Bitmap) — a graphics file format for Windows that can be edited to the pixel (good for photos)

brightness — how dark or light an image is. The computer monitor can have its brightness adjusted as well as a too dark photo.

burn — a term from the darkroom that refers to selective darkening of an image.

canvas — many programs refer to the work area for an image as the "canvas." It can be enlarged around a photo without changing the picture size.

cloning — the copying of small areas of an image and pasting them onto another area to correct a problem or to add new picture elements.

CMYK (cyan, magenta, yellow, black) — one way of defining color space in the computer based on the subtractive primary colors. Used in four-color printing processes (such as magazines and books) for optimum reproduction of photos in published materials.

color casts — an overall color that degrades an image because the color is not natural to the subject, or the image has a shift in color compared to what our eyes saw and a color balance problem.

compositing — combining different images (or parts of images) into a single image for effect.

contrast — the relationship between dark and light areas in a photo. Sharp tonal shifts from dark to light, with few middle tones, shows high contrast. When that transition is slower, showing many middle tones, the contrast is low. Contrast can also be defined over the whole image or in a small area (known as local contrast).

cropping — changing an image by cutting off unimportant parts to emphasize the subject by only keeping a portion of the original photo.

despeckle — a filter in advanced software programs that removes "speckling" or grain from an image.

distorting — changing an image by deforming or contorting the whole picture or part away from the natural appearance of the subject.

dodge — a term from the darkroom that refers to selective lightening of an image.

dpi — dots per inch. A term that tells you how many "dots" of information a device (scanner or printer, usually) can resolve or define in input or output — typically used with scanners to look at resolution of the unit.

dye-sublimation — a printing technology that results in continuous tone images. Gaseous color dyes pass through a semi-permeable membrane on the media surface. Usually results in very vibrant, stable colors.

embossing — changing an image by creating the appearance of a three-dimensional surface to the photo as if it were embossed.

feather — a way of softening the edge of a selection or effect on an image by gradually blending the edge from one side to the other.

footprint — the size of something either on the desk or on the computer. Peripherals have a footprint based on how much space they take up on the work surface; software programs have a footprint based on how much RAM they take up before they actually perform any operations.

GIF (Graphics Interchange Format) — a graphics file format that reduces resolution and color data to make

images work better on the Internet. Can have a severe negative effect on photos.

graphics board — also called a video board. The piece of hardware in the computer that controls how information is displayed on the monitor (and what monitor can be used).

half-tone — the standard way of printing photos in a book or magazine. Images are broken down into small dots described by a "line screen". Higher numbered screens (e.g., 150 lpi or lines per inch) result in better looking photos but require high quality paper to look good.

highlights — the brightest parts of a picture.

hue — the actual color of something as described by red, blue, green, etc.

inkjet — a low-priced digital printing technology, once giving low quality to match its price, but now offering superb photo printing. Tiny droplets of ink are shot at the paper to form the image.

JPEG (Joint Photographic Experts Group) — a graphics file format that compresses the file size by throwing out what the software considers redundant data. JPEG files lose image data and quality as compression increases.

lasso — a free-hand selection tool that allows you to draw any shape selected area onto an image.

layers — a way of working with a photo in the computer so that the parts of an image are on separate levels. You can adjust or delete a layer without changing anything else.

magic wand — a selection tool that examines an image for similarities and makes the selection based on matching areas adjacent to the spot you where you began the selection.

mezzotint — a special effect done to an image that breaks it up into an interesting pattern that looks like extreme grain.

morphing — the changing of an image by blending it with another so that the first photo warps and twists to match the new image, e.g., a person's face begins to look like a dog's by blending the face with the dog's.

mosaic — a special effect that breaks up the image into large blocks as if it were made of tile.

noise — a special effect from a software filter that adds the appearance of grain or other speckled effects. Looks like the "noise" you see on a television set.

panoramic — a wide-format image that creates a sweeping

view of the subject. Usually used in a horizontal manner (can be used vertically, though) so image width is 2-3 times the height or more.

PICT — a graphics file format for the Macintosh that can be edited to the pixel.

pixel — short for picture element (pix-el). The smallest element of a picture that can be controlled by the computer. Plural, pixels is often used to describe the total number of dots per entire image. Whether image an is shrunk or enlarged, this number does not change; when the image is shrunk, these finite pixels come closer together, giving a higher dpi; when image is enlarged, these pixels spread apart, giving a lower dpi.

plug-ins — special software programs that work in conjunction with an image processing program to do something better, such as create a selection or unique textures.

ppi (pixels per inch) — the number of pixels per inch in an image, often used interchangeably with dpi, usually used to describe an image's resolution.

RAM — random access memory. The computer's memory that's actually active for use in programs.

RAM requirements — the amount of RAM needed for a program to function effectively.

RGB (red, green, blue) — one way of defining color space in the computer based on the additive primary colors. The main way a computer uses color (and how all monitors display color).

resolution — the density of pixels in an image or the number of dots per inch that a device (scanner, printer) can achieve. Optical resolution is the ability of a scanner to capture detail with its physical imaging system. Interpolated resolution is detail "interpolated" or generated by software to fill in the gaps of information needed above optical resolution.

saturation — a description of the brightness or richness of a color. How pure and vivid a color is.

SCSI (small computer systems interface) — a very fast system that connects peripherals to the CPU of a computer. Pronounced "skuzzy."

shadow — the darkest parts of a photo.

sharpness — how crisp an image looks.

TIFF (tagged image file format) — a graphics file bitmap

format common to nearly all photo software programs and nearly universally interchangeable.

unsharp mask — a software filter based on an old printing technique where a special "unsharp" mask was made. It increases sharpness of an image with some control as you can adjust how much sharpness you want, at what level (radius and threshold).

USB (universal serial bus) — a newer way of connecting peripherals to the computer that promises high speed transfer of data and easier recognition of the peripheral by the computer.

INDEX

A Agfa 31

B bits 13, 15, 22, 114
black-and-white 34, 52, 56
BMP (Bitmap) 103
borders 79, 82, 84
brightness 8, 24, 38-39, 47, 48-50, 53, 69 114
brochures 87
burn 46, 49, 114

C calendars 84-85
Canon 12, 14, 70
canvas 82, 114
Castlewood 92
CCD sensor 30
cloning 43-45, 56, 114
CMYK (cyan, magenta, yellow, black) 39, 114
color
 casts 24, 39, 56, 115
 correction 39-41, 56
 saturation 40-41, 56, 69
 changing 56
compositing 61, 62, 63-69, 115
conflicts 35
contrast 8, 24, 38-39, 47, 48-50, 53, 69 114
CoolPix 29
cropping 37-38, 53, 54, 115

D demos 112-113
despeckle 26, 115
digital cameras 28-33
distorting 57, 115
dodge 46, 49, 115
dpi 13-16, 115
dye-sublimation 71-72, 115

E e-mail 94, 95-99
embossing 58, 115
Encad 72
Epson 17
equipment, choosing 23-24

F Fargo 71
feather 47, 69, 115
Feininger, Andreas 7
file formats 103
file size 16, 96-97
filters 57-60
find edges 58
flash 33
Flash Pix 22-23
floppies 89
flyers 76
footprint 115
Fuji 72

G GIF (Graphics Interchange Format) 97, 101, 104, 115
graphics board 35, 116
greeting cards 78-80

H half-tone 15, 116
hard drives 90
hardware 105-106
Hewlett-Packard 18, 25
highlights 24, 116
hue 56, 116

I images
 organizing 93
 new 64
 steps to better 53

inkjet 70-72, 116
input 11-25
Internet 94-101

J JPEG (Joint Photographic Experts Group)
 96-98, 103, 104

K Kodak 12, 31
 Konica 20

L labels 86-87
 large capacity disk drives 90-92
 lasso 46, 116
 layers 56, 109, 116
 LCD 29-31
 letter
 pictures in 74-75
 letterheads 75-76
 lockups 35
 Luna Pro 61

M magic wand 46-47, 116
 mezzotint 59, 116
 Minolta 20
 monitor settings 35
 morphing 61, 116
 mosaic 59, 116

N newsletters 83
 Nikon 12
 noise 59, 69, 116

O Olympus 28
 Optic Pro 19

P panoramic 62
 party fun 80
 Photo CD's 21-22
 PICT 104, 117
 pixel 13-15, 117
 plug-ins 82, 117
 Polaroid 12
 posters 76

ppi (pixels per inch) 13-16, 117
Princeton 36
printers
 dye-sublimation 71
 inkjet 70-72
prints 70

R RAM 35, 105-106, 117
 removable 32, 90-93
 resolution 30, 11
 retrieval 93
 RGB (red, green, blue) 17, 39-41, 117

S SanDisk 32
 saturation 40-41, 49-50, 56, 69, 117
 scanners12-13, 15, 17-19, 23-25
 scanning 24
 SCSI (small computer systems interface)
 117
 selection 45-59
 selective adjustment 49
 service bureaus 72
 shadow 24
 sharpening 26-27, 41-42
 Snappy 21
 software 34-35 105-106,
 Sony 13
 sports cards 85
 storage 32, 89-93
 Syjet 91
 Syquest 90-91

T t-shirts 77
 TIFF (tagged image file format) 103, 104,
 117

U unsharp mask 26-27, 41, 50-51, 53, 118

V viewfinder 31

W web sites 99-101, 112-113

Z Zip 90-91

Other Books from Amherst Media, Inc.

Basic 35mm Photo Guide
Craig Alesse

Great for beginning photographers! Designed to teach 35mm basics step-by-step — completely illustrated. Features the latest cameras. Includes: 35mm automatic and semi-automatic cameras, camera handling, *f*-stops, shutter speeds, and more! $12.95 list, 9x8, 112p, 178 photos, order no. 1051.

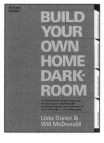

Don't Take My Picture
Craig Alesse

This is the second edition of the fun-to-read guide to taking fantastic photos of family and friends. Best selling author, Craig Alesse, shows you in clear, simple language how to shoot pictures, work with light, and capture the moment. Make everyone in your pictures look their best! $9.95 list, 6x9, 104p, 100+ photos, order no. 1099.

Build Your Own Home Darkroom
Lista Duren & Will McDonald

This classic book shows how to build a high quality, inexpensive darkroom in your basement, spare room, or almost anywhere. Information on: darkroom design, woodworking, tools, and more! $17.95 list, 8½x11, 160p, order no. 1092.

Into Your Darkroom Step-by-Step
Dennis P. Curtin

The ideal beginning darkroom guide. Easy to follow and fully illustrated each step of the way. Information on: equipment you'll need, set-up, making proof sheets and much more! $17.95 list, 8½x11, 90p, hundreds of photos, order no. 1093.

Camera Maintenance & Repair
Thomas Tomosy

A step-by-step, fully illustrated guide by a master camera repair technician. Sections include: testing camera functions, general maintenance, basic tools needed, basic repairs for accessories, camera electronics, plus "quick tips" for maintenance and more! $24.95 list, 8½x11, 176p, order no. 1158.

Camera Maintenance & Repair Book 2
Thomas Tomosy

Advanced troubleshooting and repair building on the basics covered in the first book. Includes; mechanical and electronic SLRs, zoom lenses, medium format, troubleshooting, repairing plastic and metal parts, and more. $29.95 list, 8½x11, 176p, 150+ photos, charts, tables, appendices, index, glossary, order no. 1558.

Restoring Classic & Collectible Cameras
Thomas Tomosy

A must for camera buffs and collectors! Clear, step-by-step instructions show how to restore a classic or vintage camera. Work on leather, brass and wood to restore your valuable collectibles. $34.95 list, 8½x11, 128p, b&w photos and illustrations, glossary, index, order no. 1613.

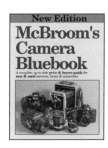

McBroom's Camera Bluebook
Mike McBroom

Comprehensive, fully illustrated, with price information on: 35mm cameras, medium & large format cameras, exposure meters, strobes and accessories. Pricing info based on equipment condition. A must for any camera buyer, dealer, or collector! $34.95 list, 8½x11, 224p, 75+ photos, order no. 1263.

Wide-Angle Lens Photography

Joseph Paduano

For everyone with a wide-angle lens or those who want one! Includes: taking exciting travel photos, creating wild special effects, using distortion for powerful images, and much more! Part of the Amherst Media's Photo-Imaging Series. $15.95 list, 7x10, 112p, glossary, index, appendices, b&w and color photos, order no. 1480.

Big Bucks Selling Your Photography

Cliff Hollenbeck

A complete photo business package for all photographers. Includes secrets to making big bucks, starting up, getting paid the right price, and creating successful portfolios! Features setting financial, marketing and creative goals. This book will help to organize business planning, bookkeeping, and taxes. $15.95 list, 6x9, 336p, order no. 1177.

Great Travel Photography

Cliff and Nancy Hollenbeck

Learn how to capture great travel photos from the Travel Photographer of the Year! Includes helpful travel and safety tips, equipment checklists, and much more! Packed full of photo examples from all over the world! Part of the Amherst Media's Photo-Imaging Series. $15.95 list, 7x10, 112p, b&w and color photos, index, glossary, appendices, order no. 1494.

Telephoto Lens Photography

Rob Sheppard

A complete guide for telephoto lenses! This book shows you how to take great wildlife photos, portraits, sports and action shots, travel pics, and much more! Features over 100 photographic examples. $17.95 list, 8½x11, 112p, b&w and color photos, index, glossary, appendices, order no. 1606.

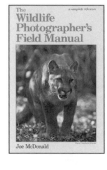

The Wildlife Photographer's Field Manual

Joe McDonald

The complete reference for every wildlife photographer. A practical, comprehensive, easy-to-read guide with useful information, including: the right equipment and accessories, field shooting, lighting, focusing techniques, and more! Features special sections on insects, reptiles, birds, mammals and more! $14.95 list, 6x9, 200p, order no. 1005.

Camcorder Business

Mick and George A. Gyure

Make money with your camcorder! This book covers everything you need to start a successful business using your camcorder. Includes: editing, mixing sound, dubbing, technical and business tips, and much more! Also features information on covering a wedding or other special event for a client, legal and industrial videos, and more. $17.95 list, 7x10, 256p, order no. 1496.

Infrared Photography Handbook

Laurie White

Covers black and white infrared photography: focus, lenses, film loading, film speed rating, heat sensitivity, batch testing, paper stocks, and filters. Black & white photos illustrate how IR film reacts in portrait, landscape, and architectural photography. $24.95 list, 8½x11, 104p, 50 b&w photos, charts & diagrams, order no. 1419.

The Art of Infrared Photography / 4th Edition

Joe Paduano

A practical, comprehensive guide to the art of infrared photography. Tells what to expect and how to control results. Includes: anticipating effects, color infrared, digital infrared, using filters, focusing, developing, printing, handcoloring, toning, and more! $29.95 list, 8½x11, 112p, order no. 1052.

Infrared Nude Photography
Joseph Paduano

A stunning collection of images with informative how-to text. Over 50 infrared photos presented as a portfolio of classic nude work. Shot on location in natural settings, including the Grand Canyon, Bryce Canyon and the New Jersey Shore. $29.95 list, 8½x11, 96p, over 50 photos, order no. 1080.

Black & White Nude Photography
Stan Trampe

This book teaches the essentials for beginning fine art nude photography. Includes info on finding your first models, selecting equipment, scenarios of a typical shoot, and more! Includes 60 photos taken with b&w and infrared films. $24.95 list, 8½x11, 112p, index, order no. 1592.

Swimsuit Model Photography
Cliff Hollenbeck

A complete guide to swimsuit model photography. Includes: finding and working with models, selecting equipment, posing, props, backgrounds, and much more! By the author of *Big Bucks Selling Your Photography* and *Great travel Photography*. $29.95 list, 8½x11, 112p, over 100 b&w and color photos, index, order no. 1605.

Glamour Nude Photography
Robert and Sheila Hurth

Create stunning nude images! Robert and Sheila Hurth guide you through selecting a subject, choosing locations, lighting, and shooting techniques. Includes information on posing, equipment, makeup and hair styles, and much more! $24.95 list, 8½x11, 144p, over 100 b&w and color photos, index, order no. 1499.

Wedding Photographer's Handbook
Robert and Sheila Hurth

The complete step-by-step guide to succeeding in the exciting and profitable world of wedding photography. Packed with shooting tips, equipment lists, must-get photo lists, business strategies, and much more! $24.95 list, 8½x11, 176p, index, b&w and color photos, diagrams, order no. 1485.

Lighting for People Photography
Stephen Crain

The complete guide to lighting. Includes: set-ups, equipment information, how to control strobe and natural lighting, and much more! Features diagrams, illustrations, and exercises for practicing the lighting techniques discussed in each chapter. $29.95 list, 8½x11, 112p, b&w and color photos, glossary, index, order no. 1296.

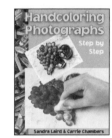

Handcoloring Photographs Step-by-Step
Sandra Laird & Carey Chambers

Learn to handcolor photographs step-by-step with the new standard handcoloring reference. Covers a variety of coloring media. Includes colorful photographic examples. $29.95 list, 8½x11, 112p, 100+ color and b&w photos, order no. 1543.

Special Effects Photography Handbook
Elinor Stecker Orel

Create magic on film with special effects! Little or no additional equipment required, use things you probably have around the house. Step-by-step instructions guide you through each effect. $29.95 list, 8½x11, 112p, 80+ color and b&w photos, index, glossary, order no. 1614.

Achieving the Ultimate Image
Ernst Wildi

Ernst Wildi shows how any photographer can take world class photos and achieve the ultimate image. Features: exposure and metering, the Zone System, composition, evaluating an image, and much more! $29.95 list, 8½x11, 128p, 120 B&W and color photos, index, order no. 1628.

Black & White Portrait Photography
Helen Boursier

Make money with B&W portrait photography. Learn from top B&W shooters! Studio and location techniques, with tips on preparing your subjects, selecting settings and wardrobe, lab techniques, and more! $29.95 list, 8½x11, 128p, 130+ photos, index, order no. 1626.

Profitable Portrait Photography
Roger Berg

Learn to profit in the portrait photography business! Improves studio methods, shows lighting techniques and posing, and tells how to get the best shot in the least amount of time. A step-by-step guide to making money. $29.95 list, 8½x11, 104p, 120+ B&W and color photos, index, order no. 1570.

More Photo Books Are Available!
Write or fax for a *FREE* catalog:

AMHERST MEDIA, INC.
PO Box 586
Amherst, NY 14226 USA

Fax: 716-874-4508

Ordering & Sales Information:

Individuals: If possible, purchase books from an Amherst Media retailer. Write to us for the dealer nearest you. To order direct, send a check or money order with a note listing the books you want and your shipping address. U.S. & overseas freight charges are $3.50 first book and $1.00 for each additional book. Visa and Master Card accepted. New York state residents add 8% sales tax.

Dealers, distributors & colleges: Write, call or fax to place orders. For price information, contact Amherst Media or an Amherst Media sales representative. Net 30 days.

All prices, publication dates, and specifications are subject to change without notice.

Prices are in U.S. dollars. Payment in U.S. funds only.

Amherst Media's Customer Registration Form

Please fill out this sheet and send or fax to receive free information about future publications from Amherst Media.

CUSTOMER INFORMATION

DATE

NAME

STREET OR BOX #

CITY **STATE**

ZIP CODE

PHONE () **FAX** ()

OPTIONAL INFORMATION

I BOUGHT *COMPUTER PHOTOGRAPHY HANDBOOK* **BECAUSE**

I FOUND THESE CHAPTERS TO BE MOST USEFUL

I PURCHASED THE BOOK FROM

CITY **STATE**

I WOULD LIKE TO SEE MORE BOOKS ABOUT

I PURCHASE [] **BOOKS PER YEAR**

ADDITIONAL COMMENTS

FAX to: 1-800-622-3298

①

②

Name_____
Address_____
City_____State_____
Zip_____ — _____

**Amherst Media, Inc.
PO Box 586
Buffalo, NY 14226**

③